THE
BEE
AND THE
SUN

ALSO BY CATHERINE HYDE

The Hare and the Moon

THE
BEE
AND THE
SUN

A Calendar of Paintings

CATHERINE
HYDE

ZEPHYR
An Imprint of Head of Zeus

First published in the UK in 2021 by Zephyr, an imprint of Head of Zeus Ltd

9 7 5 3 1 2 4 6 8

A catalogue record for this book is available from the British Library.

ISBN (HB) 9781800240841
ISBN (E) 9781800240834

Design by Heather Ryerson
Printed and bound in Italy by L.E.G.O.

Head of Zeus Ltd
5-8 Hardwick Street
London EC1R 4RG
www.headofzeus.com

For Poppy and Smidge, who love the sun

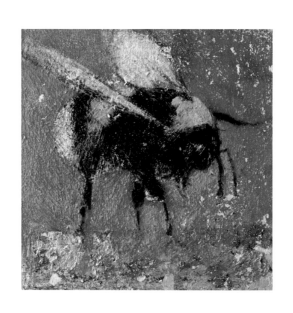

Ask the wild bee
about the dance upon the petal.

Ask the wild bee
how the constellations rise
from the flowers of the mountain.

Ask the wild bee
where to find the amber necklace
and the golden circle.

Ask the wild bee
about the roots beneath the earth
and the solitary heart.

Ask the wild bee
what the Wise Ones knew.

JANUARY

Under January's pale sun
the queen is alone, meadow sweet,
rich with secrets.

And she hums,

The Cool Sun, The Arctic Sun
The Wintery Sun, The Ageless Sun
The Faint Sun, The Solitary Sun

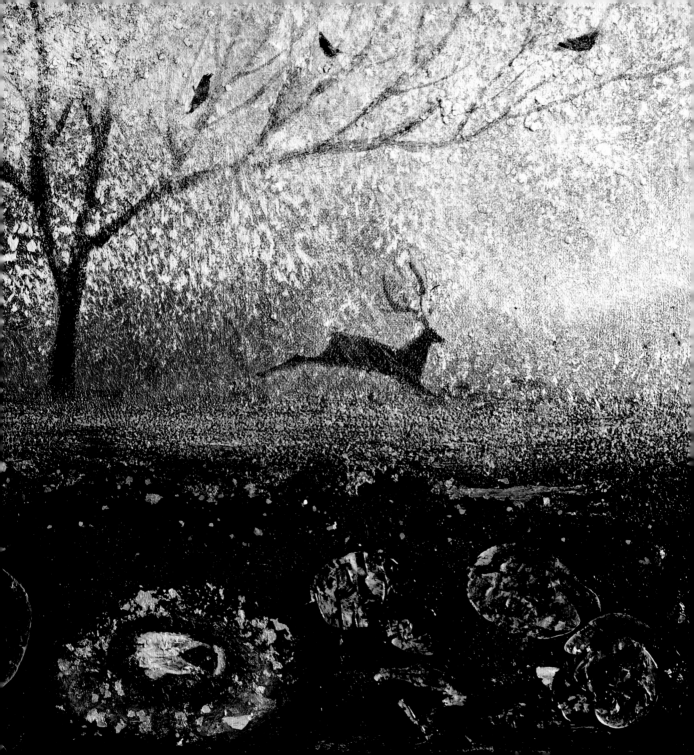

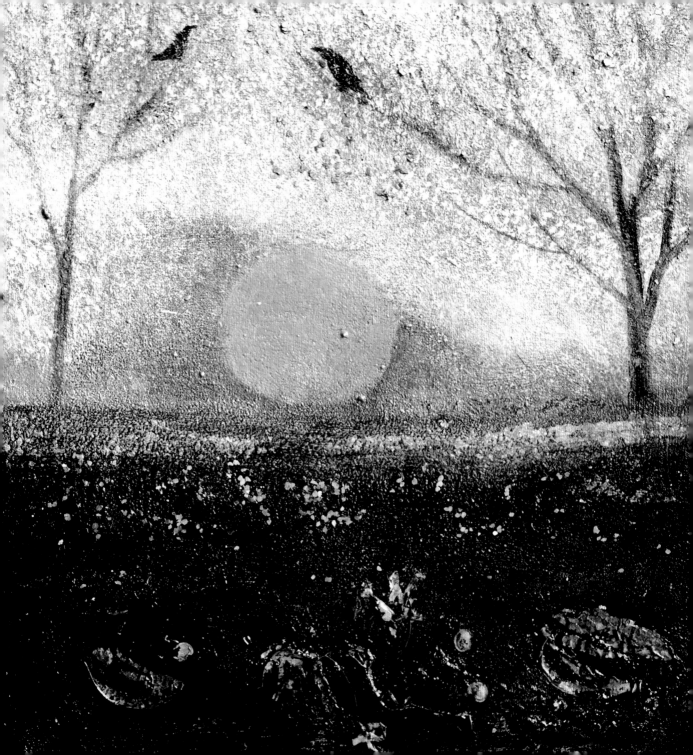

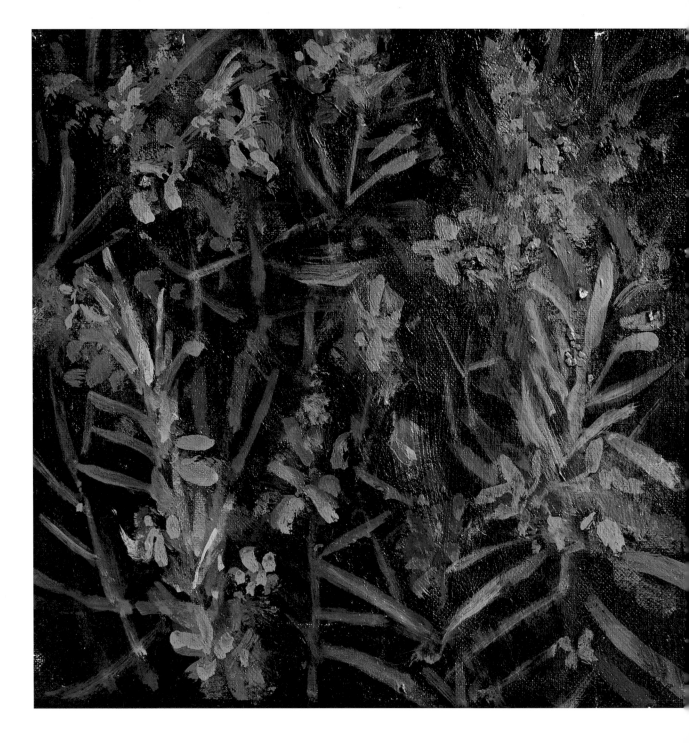

'Rosmarinus' means 'dew of the sea' in Latin.

An old saying, 'Where Rosemary flourishes, the Woman rules,' meant it was believed that rosemary could not grow in the garden of the home unless the mistress was the master.

Considered a holy herb by the Romans, rosemary is known as a plant of remembrance, used both in brides' bouquets and in funeral rites.

Rosemary was given as a gift for New Year's Day, along with an orange, stuck with cloves.

ROSEMARY

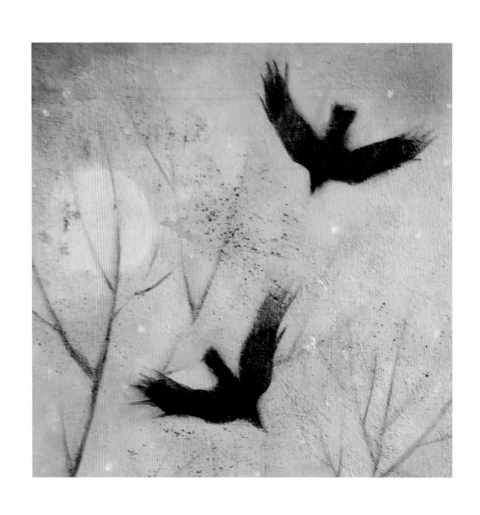

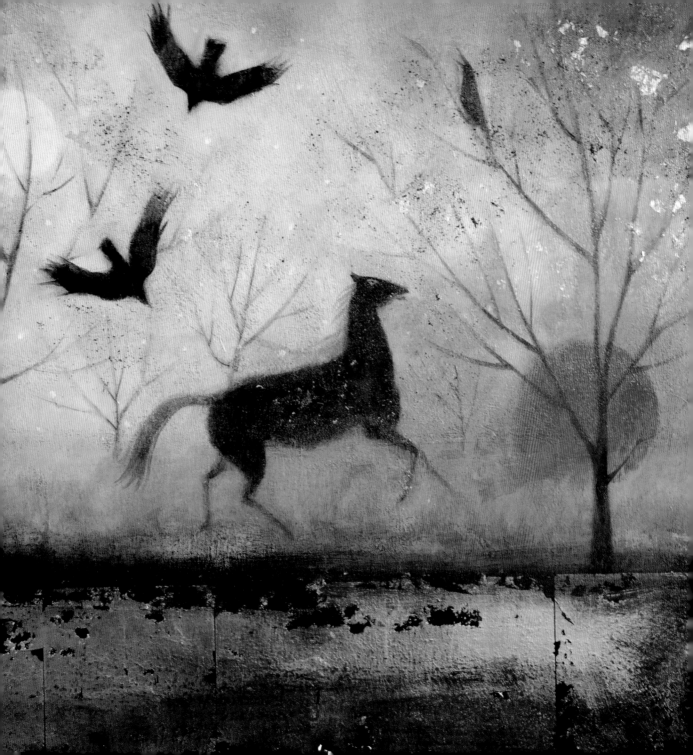

This is the place where the bee dreams.

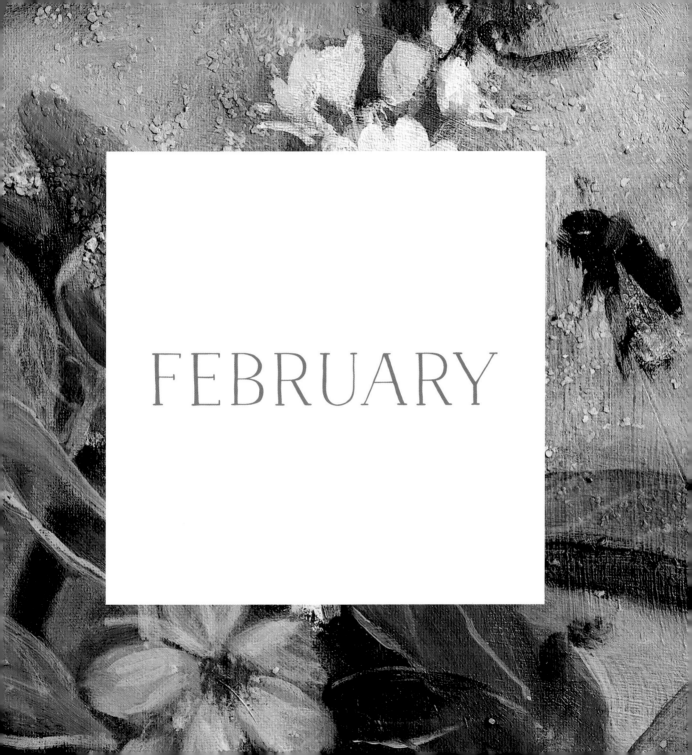

FEBRUARY

She slumbers,
sensing spring through the drumming rain,
as Orion sinks his shoulder west.

And she hums,

The Ivory Sun, The Ice Sun
The Elusive Sun, The Glassy Sun
The Quiet Sun, The Lime Sun

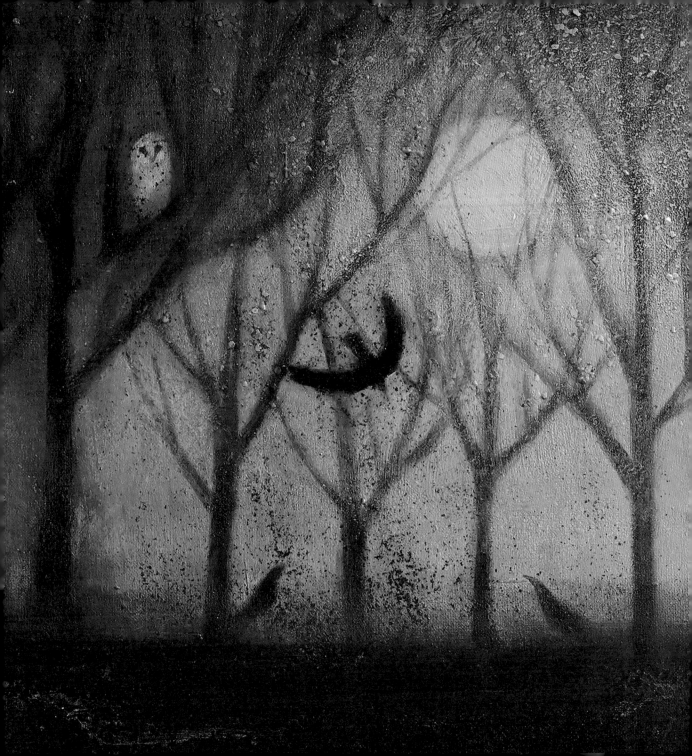

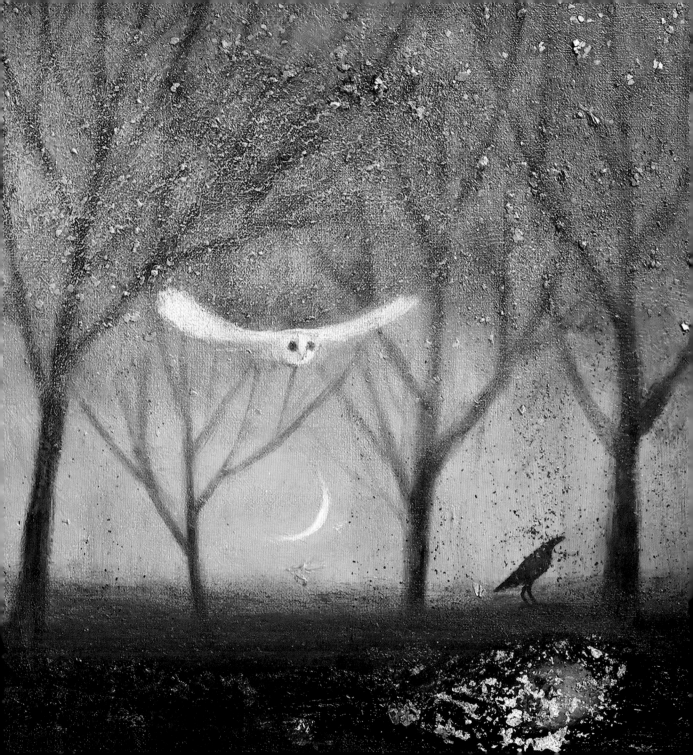

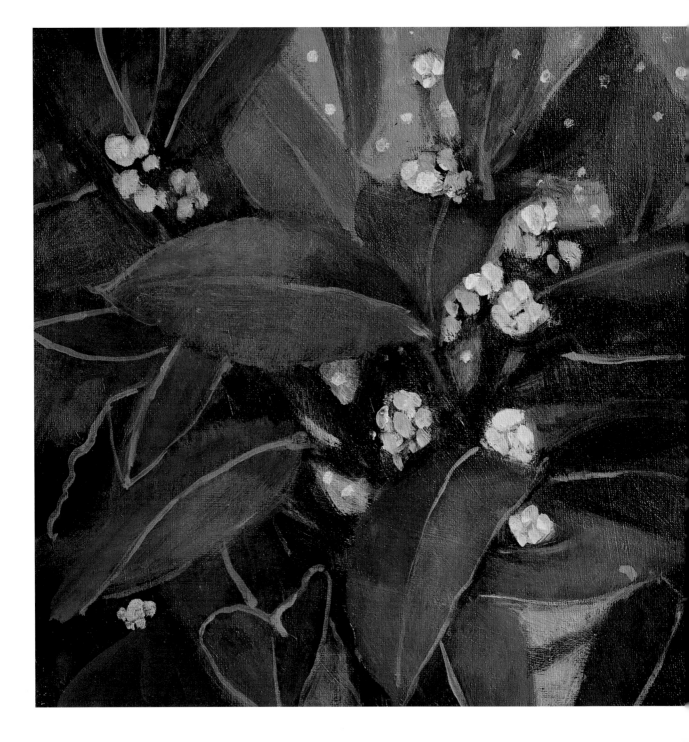

The Greek word for bay is 'dhafni', after the nymph Daphne, who was changed into a bay laurel tree to protect her from the unwanted advances of Apollo.

Bay signified courage and strength and was treasured by the Roman gods, who wore sprigs of bay as crowns to represent their high status.

The leaves of bay are known for their aromatic sweetness. Their pale-yellow flowers are especially loved by bees and butterflies.

BAY

Also called: holy basil and herb of love.

This sun-loving and popular herb was considered a witches' plant in ancient times.

To the Greeks and Romans, basil was a herb of anger and insanity. In European folklore, it was associated with the devil, leading to the French idiom, 'semer le baslic' – 'to sow the basil' – which means to rant or slander.

BASIL

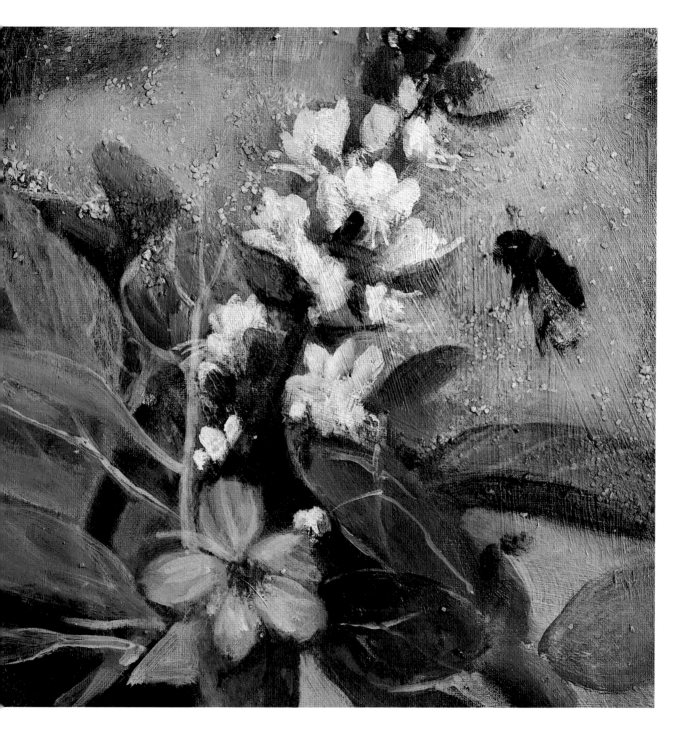

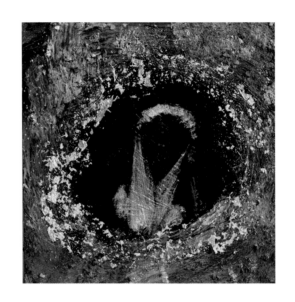

This is the place where the bee stirs.

MARCH

Cock crow trumpets the sunrise.
Drowsy, she sails on giddy wings gorging
where the wild catkins glow.

And she hums,

The Young Sun, The Sherbet Sun
The Hopeful Sun, The Radiant Sun
The Glad Sun, The Emerald Sun

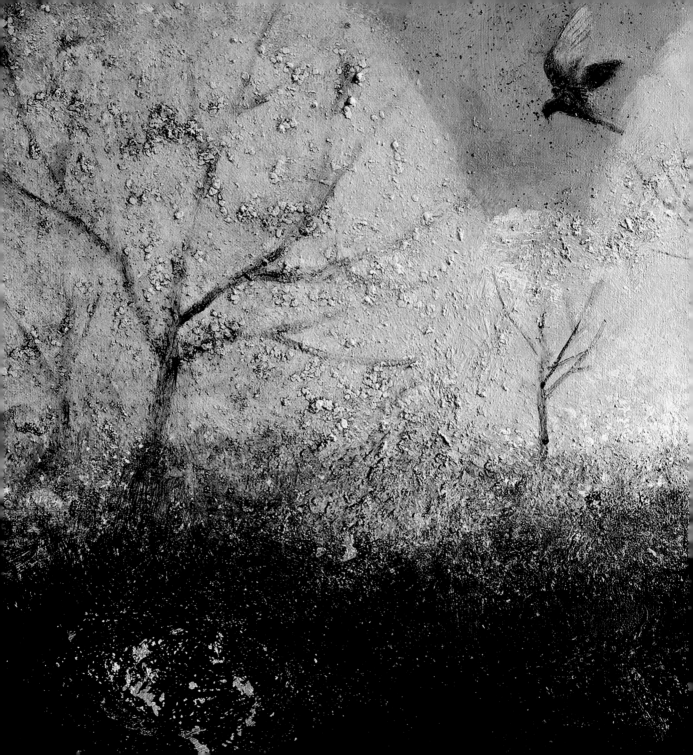

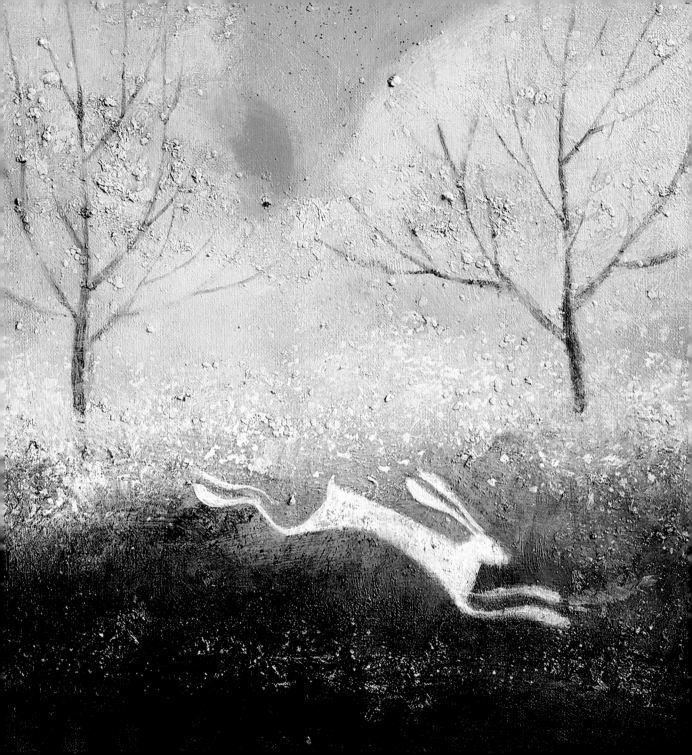

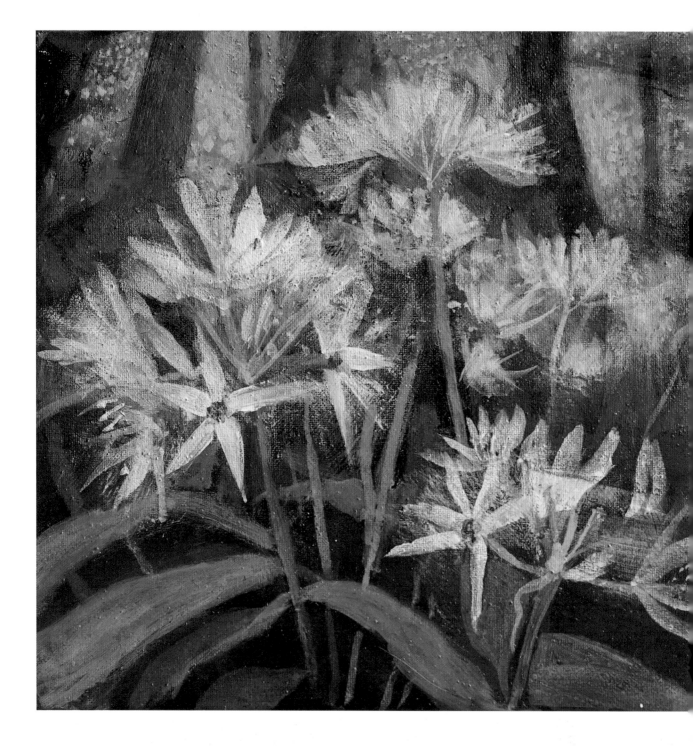

Also called: ransoms, bear leek, fountain of youth, buckrams, wood garlic, bear's garlic, cure-all.

It was said that bears, wild boar and badgers ate wild garlic to regain their strength after winter hibernation.

Milder than its conventional cousin, this foraged plant has been used traditionally as a spring tonic for its blood purifying qualities.

In Ireland, wild garlic was woven into thatch to ward off fairies and to bring good luck.

WILD GARLIC

Also called: the bee nettle, stingless nettle, blind nettle, white archangel and henbit dead nettle.

This plant looks just like the common nettle but does not sting.

On sunny days the flowers produce a large amount of nectar, making them very attractive to bees but also a wayside treat for foragers and walkers.

This is where fairies sleep. They place their slippers on the underside of the flowers.

WHITE DEAD NETTLE

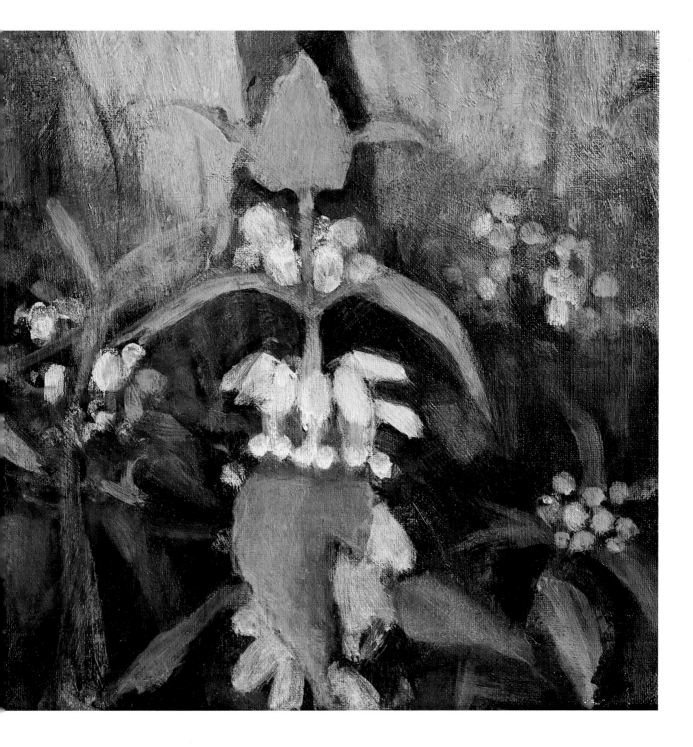

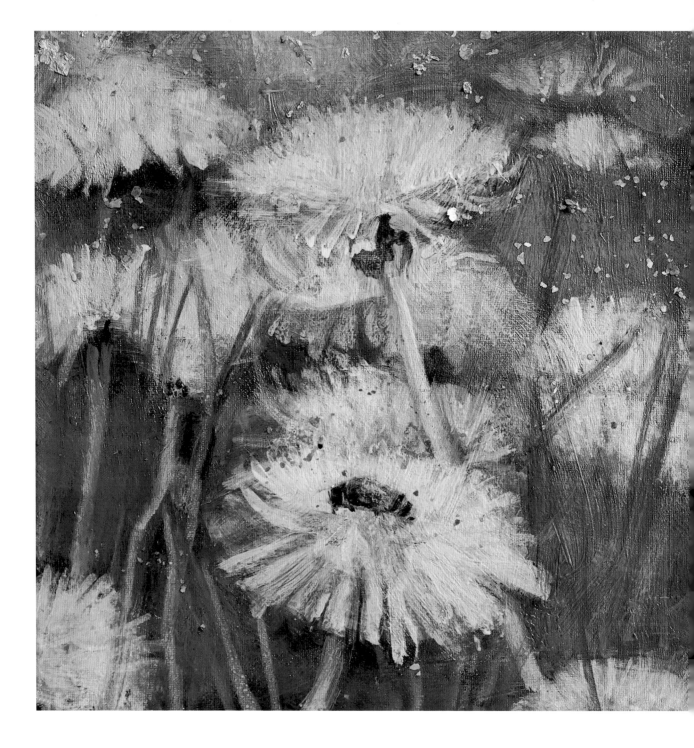

Also called: dent du lion, fairy clocks.

The shepherd's clock – the dandelion flower opens
an hour before sunrise and closes at dusk.

Tell the time by blowing the seeds off the 'clock'.

The tallest dandelion stalk a child can find in early
spring will be how much taller they'll grow that year.

Woven into a wedding bouquet, dandelions bring good
luck to the couple.

DANDELION

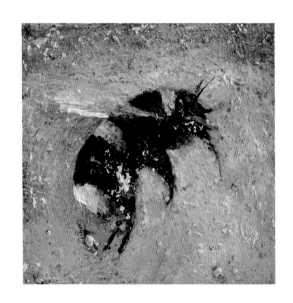

This is the place where the bee unfolds.

APRIL

Soft showers nourish her earthy nest,
a womb of pollen and nectar, filled with a working promise.

And she hums,

The Spring Sun, The Primrose Sun
The Radiant Sun, The Splendid Sun
The Genial Sun, The Newborn Sun

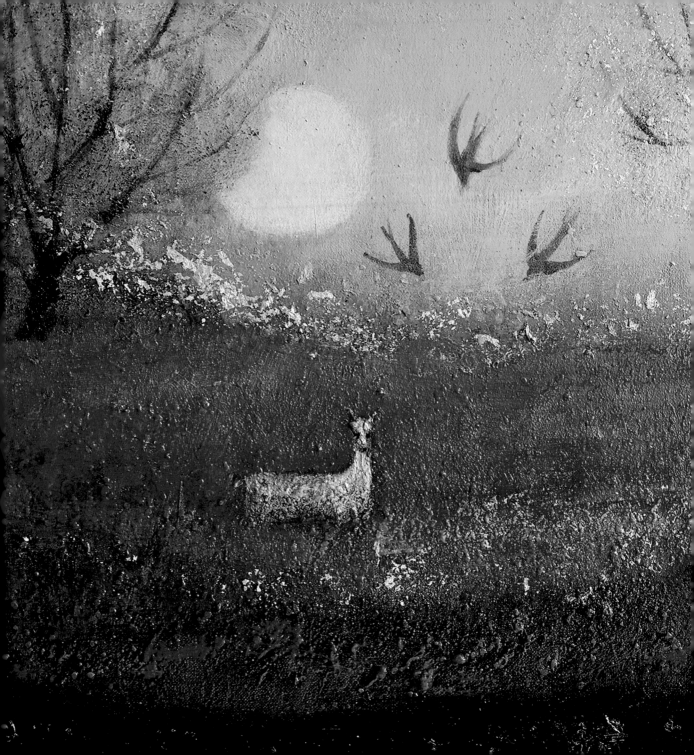

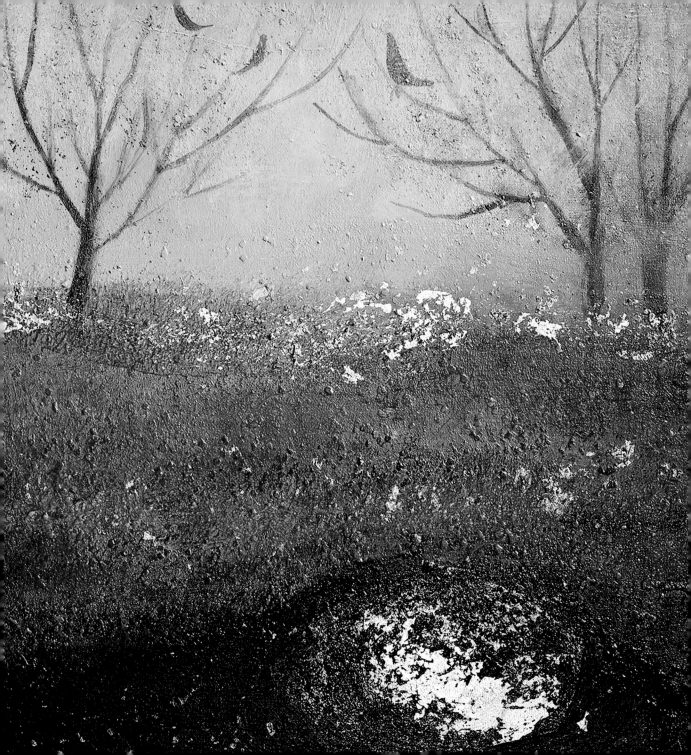

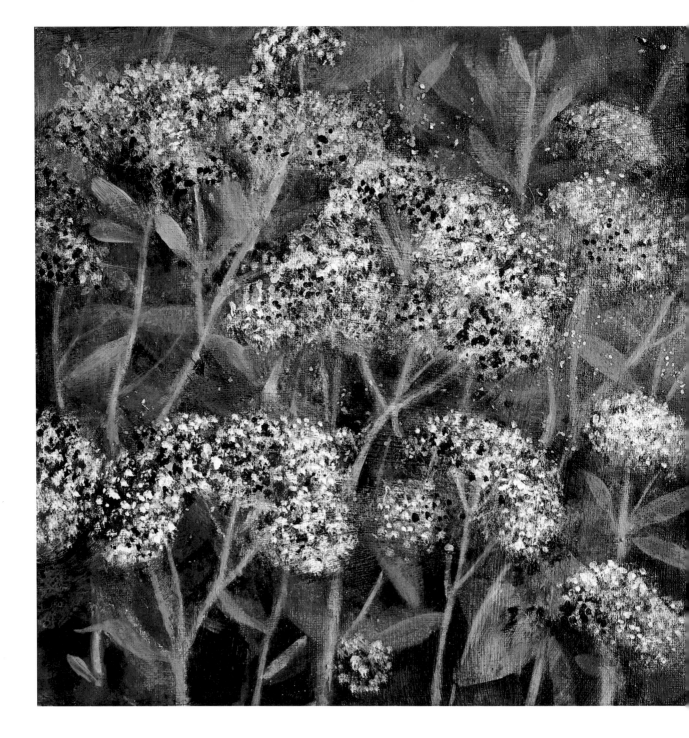

Also called: wild marjoram.

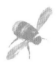

The name oregano comes from the Greek meaning 'joy of the mountains', 'oros' for mountains, 'ganos' for joy.

Oregano blooms yield a reddish-brown dye.

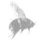

Bees feature in folklore around the world, and are associated with everything from wisdom and poetry to death and abundance.

OREGANO

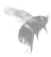

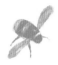
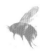

Also called: bee balm, horsemint, oswego tea.

Well-known as a medicinal herb and for flavouring
Earl Grey tea.

Wild bergamot's masses of pale-mauve blooms are
attractive to butterflies, bees and other pollinating insects.

Honey played an important role in guiding the Ancient
Egyptians in the afterlife. Bees, beehives and bee relics,
along with honey, were considered funerary gifts for the
dead. The Romans, Hindus and Chinese also had rituals
connecting honeybees, honey and death.

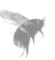

WILD BERGAMOT

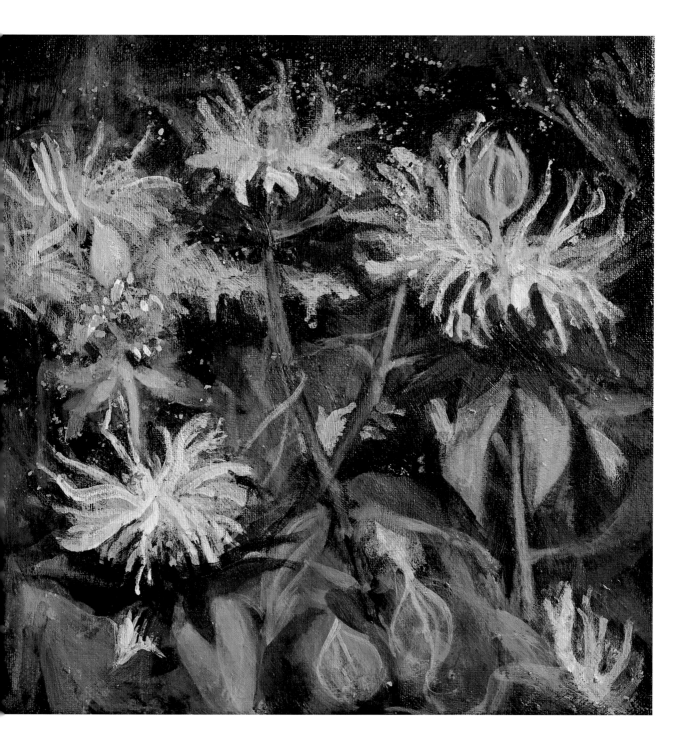

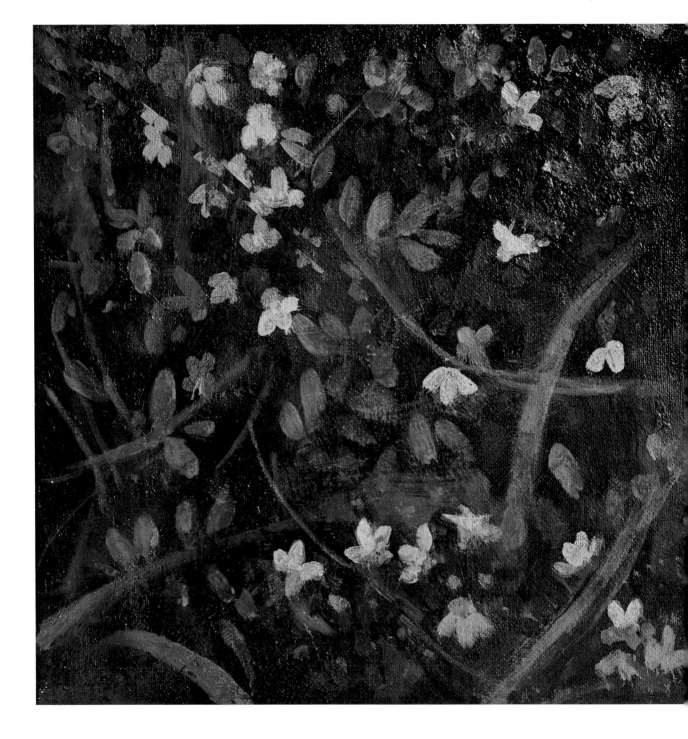

Thyme has antiseptic qualities and was used as an embalming herb in Ancient Egypt. In many countries, it was placed in coffins to ensure passage into the next world.

Greek athletes were said to have applied thyme, or oil of thyme, to their bodies to improve their courage.

In medieval days, wild thyme was thought to be under the control of fairies and therefore dangerous to bring into the house.

WILD THYME

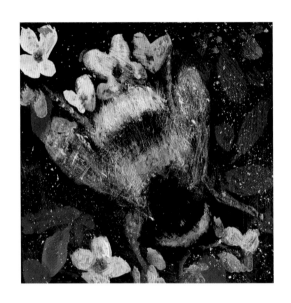

This is the place where the bee drinks.

MAY

The golden circle catches fire,
filling the air's green blood with the singing of bees.

And she hums,

The Buttercup Sun, The Magical Sun
The Glorious Sun, The Scented Sun
The Lovers Sun, The Gorgeous Sun

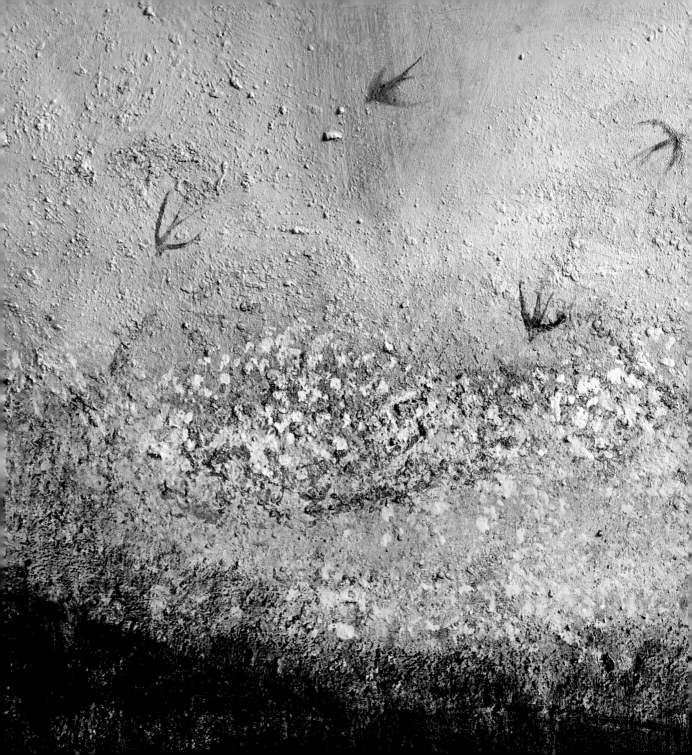

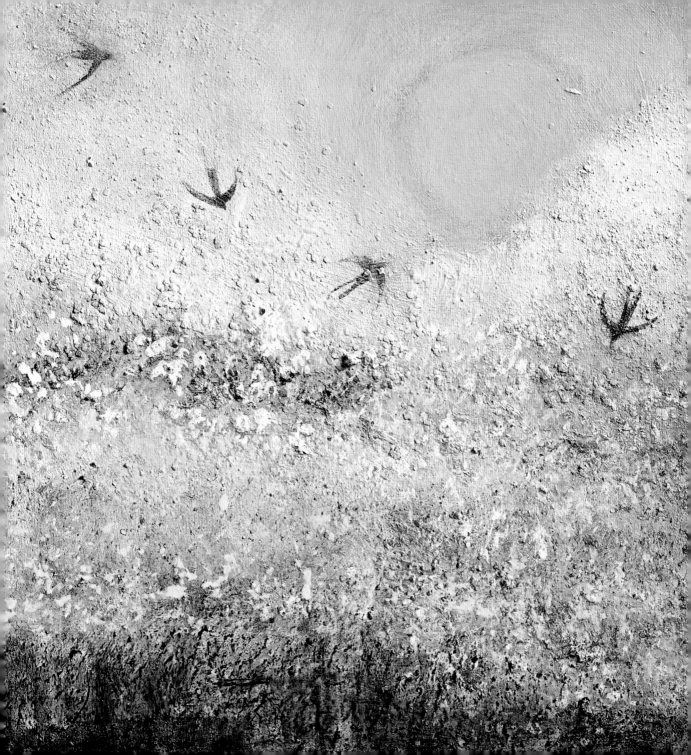

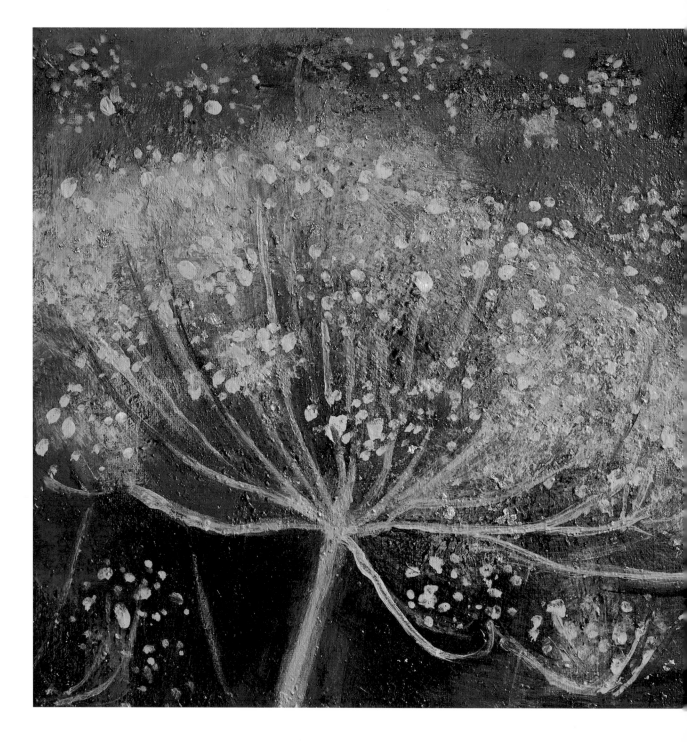

A healing, culinary and protective herb, fennel was traditionally believed to strengthen sight.

In medieval times, it was used to ward against witchcraft and was hung over doors on Midsummer's Eve to protect from evil spirits.

Bees were said to feed on the honeydew that dripped from Yggdrasil, the World Tree, in the Norse *Poetic Edda*.

FENNEL

Also called: tall mallow, cheese-cake, flibberty gibbet, high mallow.

The Celts placed mallow flowers over the eyes of their dead to prevent evil spirits from entering.

Mallow was used both as an antidote to love potions and to protect against demons, possession and black magic.

The French word for mallow is 'mauve' which is where we get the colour mauve from – a shade of purple matching the mallow's flowers.

MALLOW

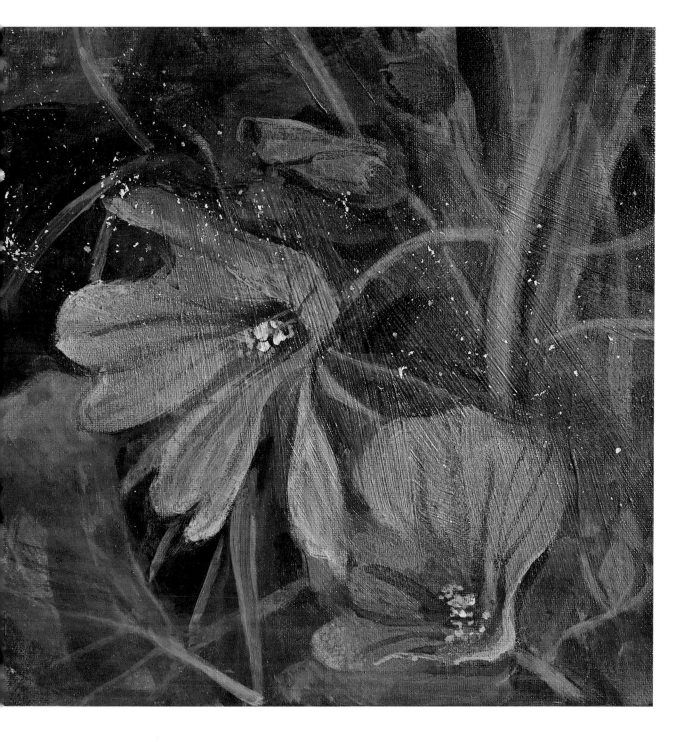

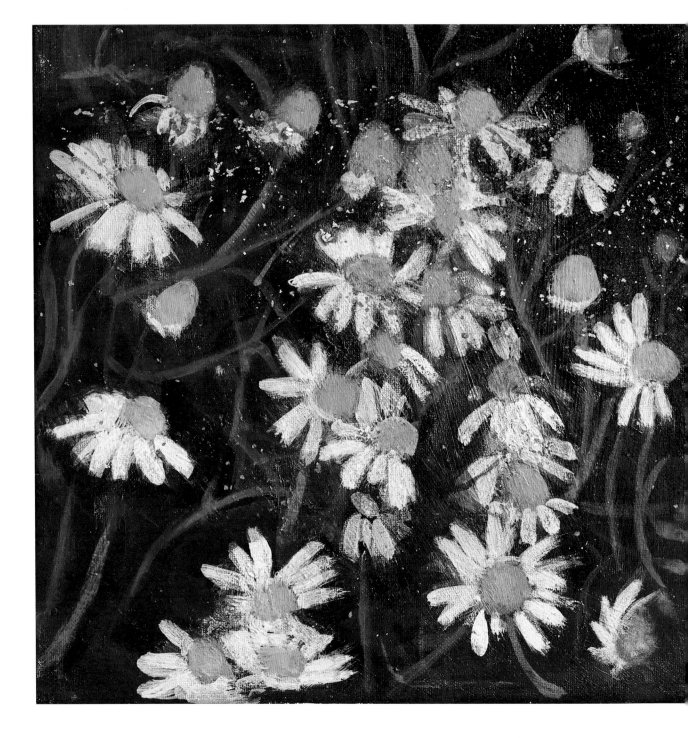

Also called: Earth apple, whig plant, Maythen,
father of the ground.

One of the nine sacred herbs of the Anglo-Saxons.

The Ancient Egyptians believed chamomile was a sacred gift
from the sun god, Ra. They used it to treat fevers and heatstroke,
and it was also used in the mummifying process.

Chamomile is prized for its apple-like fragrance and has been
grown in sweet-scented lawns and seats for centuries.

'Like a chamomile bed,
the more it is trodden,
the more it will spread.'

CHAMOMILE

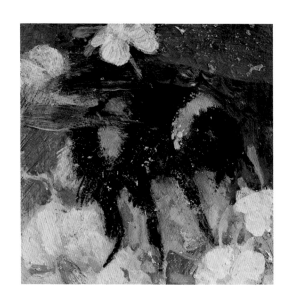

This is the place where the bee dances.

JUNE

Daisy-bright, clover-scented,
her wings are flower-flecked, thick with pollen,
as a new Persephone stirs.

And she hums,

The Golden Sun, The Solstice Sun
The Great Sun, The Genial Sun
The Pollen Sun, The Midsummer Sun

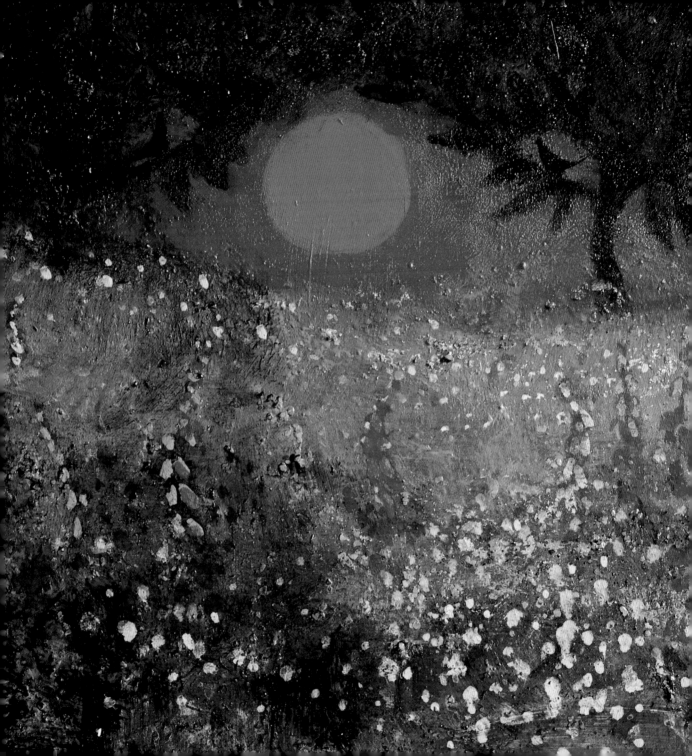

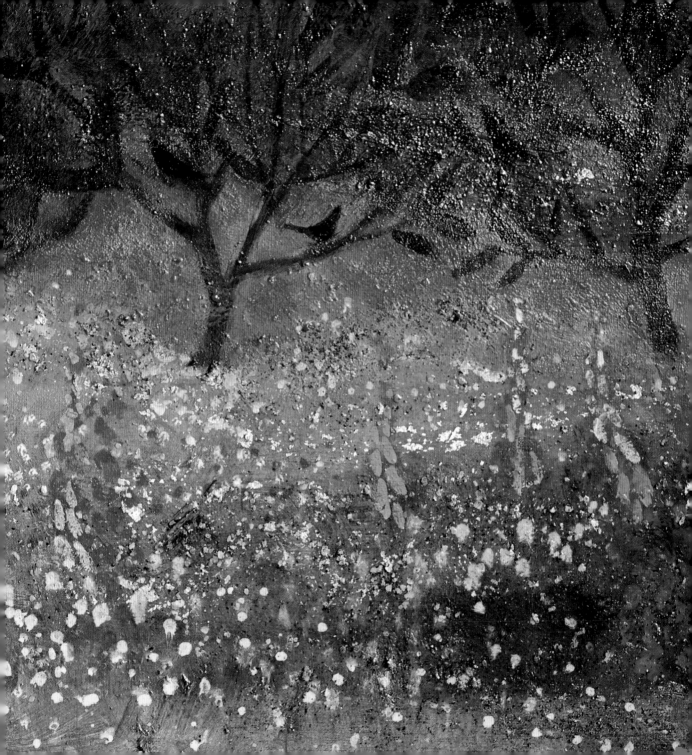

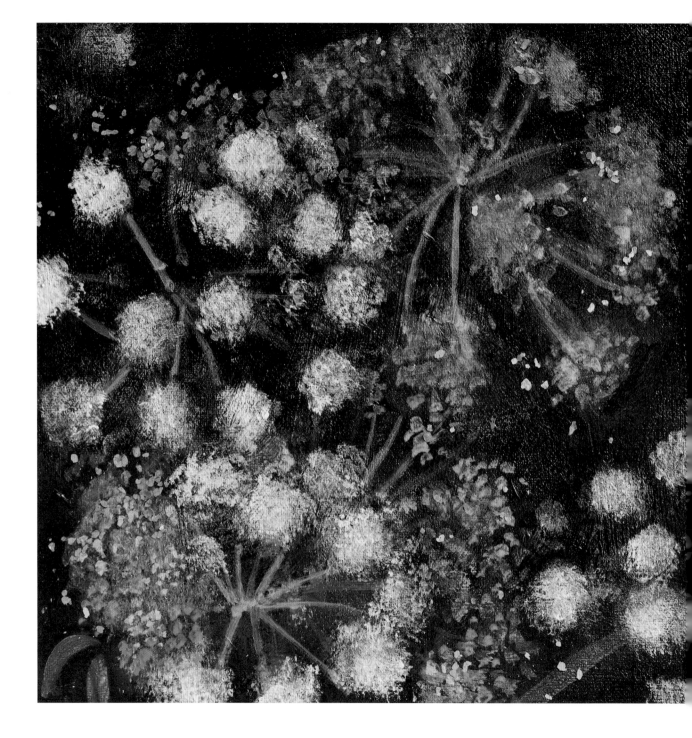

Also called: archangel, masterwort, ground ash, Holy Ghost root, archangel root, dong quai, root of the Holy Ghost.

It was believed that the archangel Michael appeared in a vision and told of the plant's use against the plague.

John Gerard, the seventeenth century botanist, claimed that it 'cureth the bitings of mad dogs and all other venomous beasts'.

Peasant children wore angelica leaf necklaces to protect them from illness and witchcraft.

ANGELICA

Also called: mountain tobacco, leopard's bane, wolfsbane.

Soother of bruises, aches and sprains.

The word arnica comes from the Greek 'arnikis' which
means lamb coat. This may refer to the flower's furry sepals.

'A swarm of bees in May is worth a load of hay,
a swarm of bees in June is worth a silver spoon,
a swarm of bees in July is not worth a fly.'

ARNICA

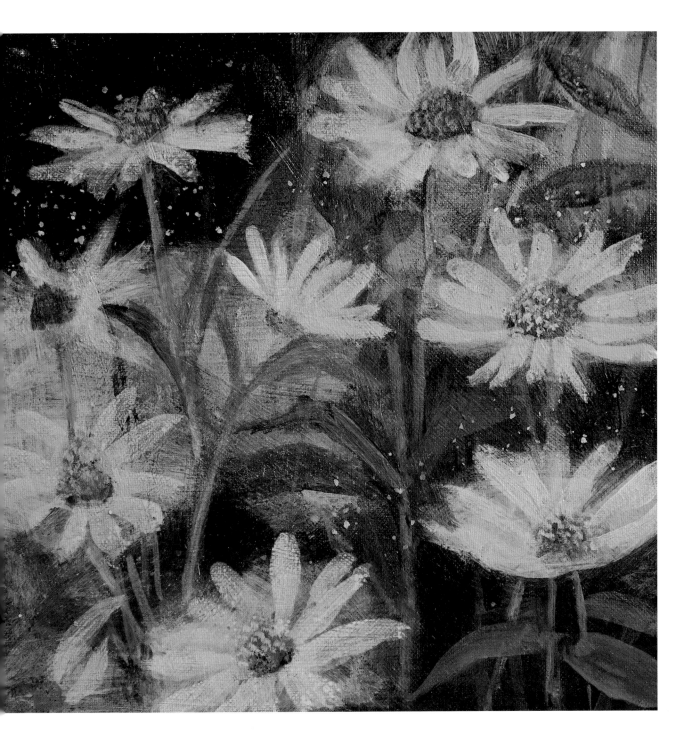

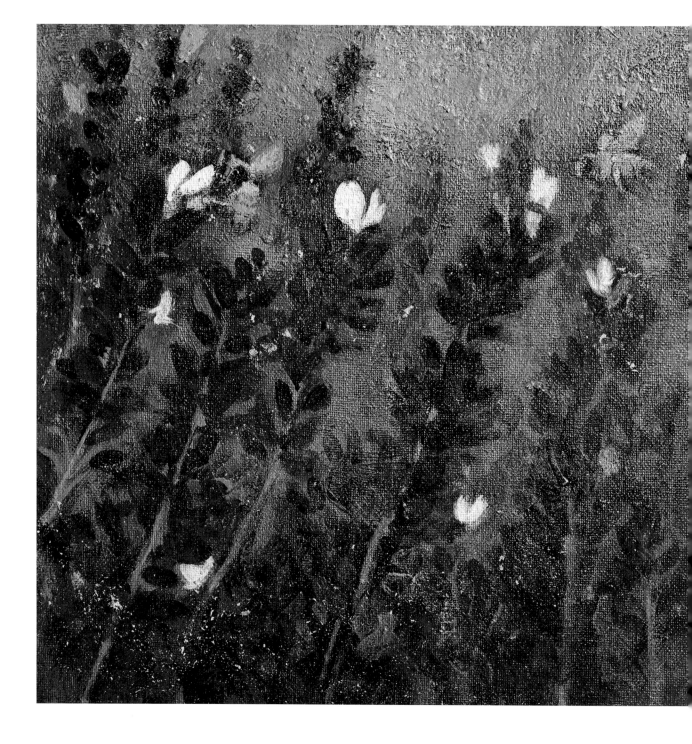

Also called: elf leaf, nard, nardus and spike.

Named from the Latin 'lavare', to wash, lavender is prized for its therapeutic properties to reduce stress and insomnia and for its ability to clean deep wounds and encourage healing.

Queen Elizabeth I demanded fresh lavender at her table throughout the year, and rich and poor used it to scent bed linens and clothing.

Lavender was hung above the door to protect against evil spirits and to summon fairies on Midsummer's Eve.

LAVENDER

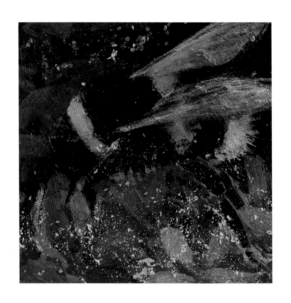

This is the place where the bee sings.

JULY

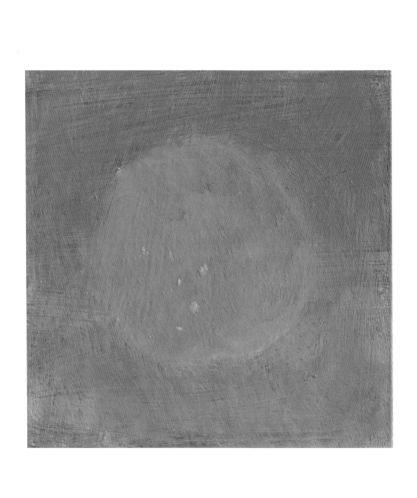

The trees stand, dark gods of the fields,
listening to the molten pulse of the nest.

And she hums,

The Languid Sun, The Balmy Sun
The Sultry Sun, The Wonderful Sun
The Opulent Sun, The Marigold Sun

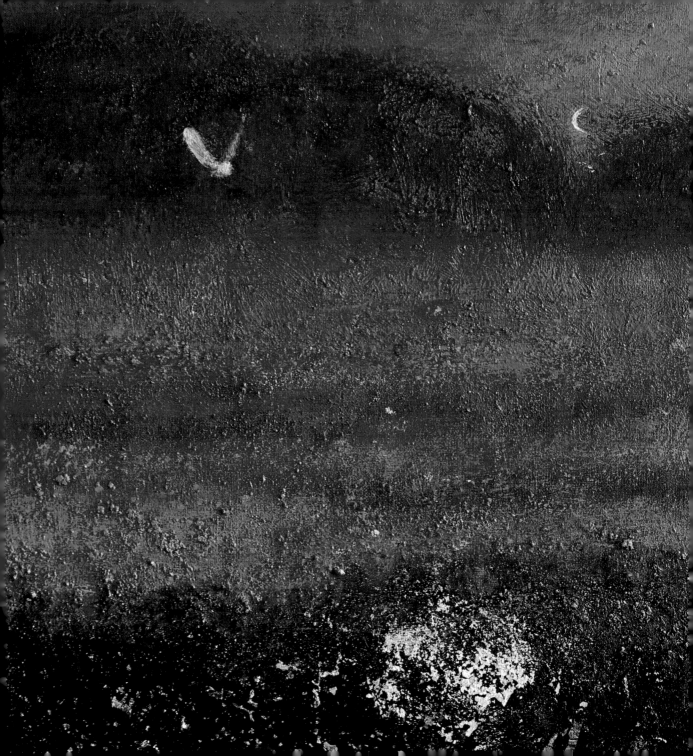

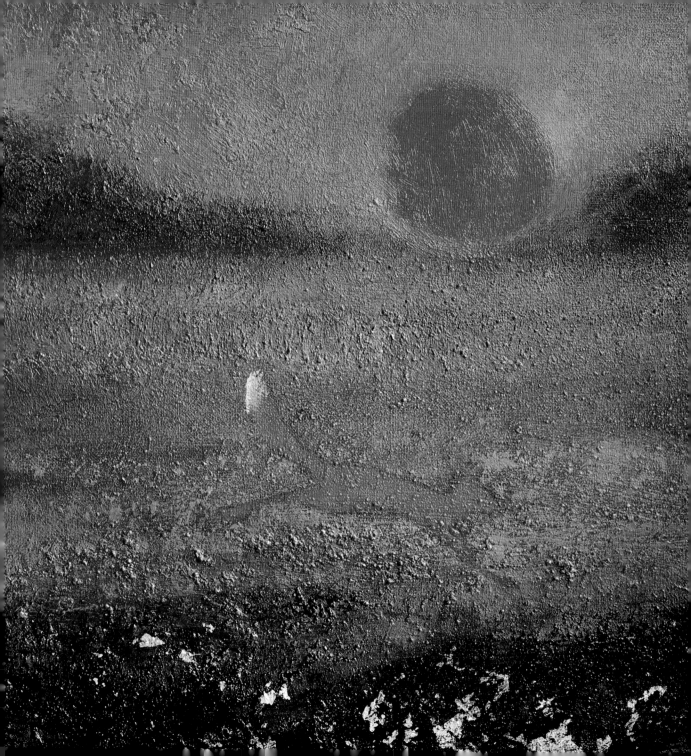

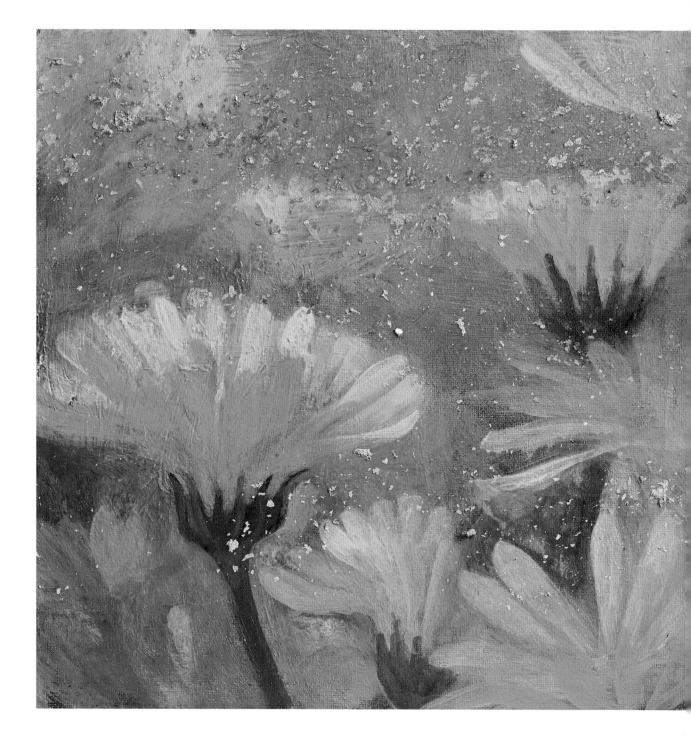

Also called: marigold, ruddles, pot marigold, English marigold, poet's marigold, husbandman's dial, Marybud, merrybud, Marygold, summer's bride.

Still a much-loved and used 'herb of the sun', calendula has long been revered as a potent medicinal. The Ancient Egyptians used it to rejuvenate their skin, the Greeks and Romans as a culinary garnish.

The vibrant yellow flowers were used as a natural dye for hair, cheese and fabrics – a poor man's saffron.

It is the traditional 'he loves me, he loves me not' flower and a good addition to dream pillows.

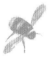

CALENDULA

Also called: mead wort, queen of the meadow, bride wort,
pride of the meadow, summer's farewell, and old man's pepper.

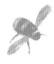

The name comes from the Anglo-Saxon 'meodu-swete', meaning
'mead sweetener', because it was used to flavour mead, beer and wine.

Meadowsweet was one of the sacred herbs of the druids,
traces of it have been found in Bronze Age burials.

The scent of meadowsweet is said to have the power to grant second
sight and the ability to converse with the fairies.

Blodeuedd (Flower Face), in *The Mabinogion*, was a beautiful woman
created out of oak blossom, broom and meadowsweet and later turned
into an owl, shunned by all other birds.

MEADOWSWEET

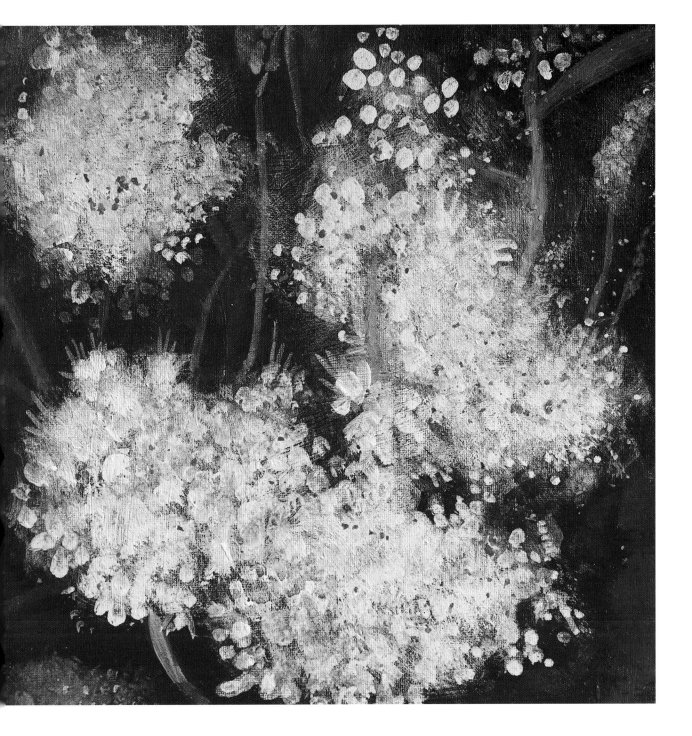

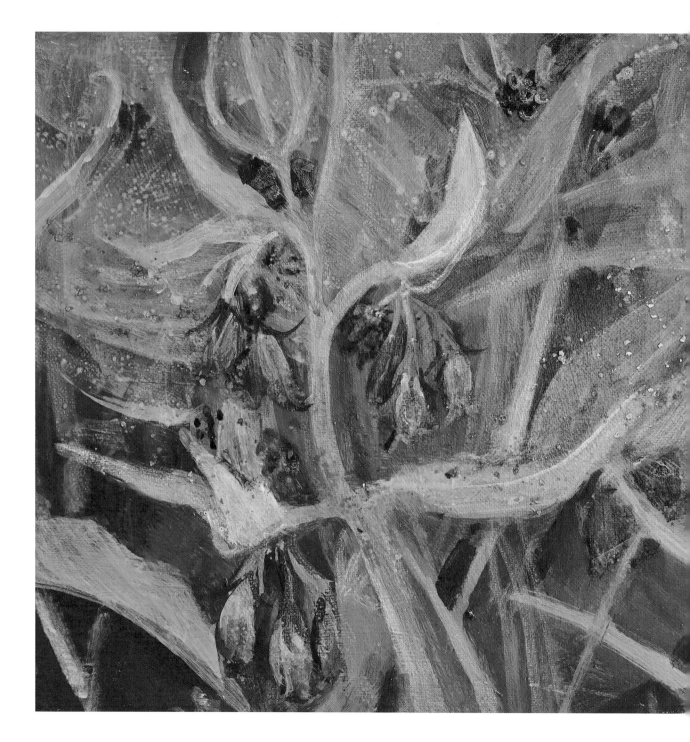

Also called: knitbone, back wort, blackwort, ass ears, bruise wort, slippery wort, pig weed, healing herb.

The name derives from the Latin 'conferre' meaning 'come together', and comfrey was grown for its healing qualities by the Greeks and Romans.

Comfrey is traditionally used by travellers for protection. A comfrey leaf in your luggage ensures it isn't lost or stolen.

COMFREY

This is the place where the bee settles.

AUGUST

Twilight nets the setting sun,
an amber necklace among the singing stars.

And she hums,

The Honeycomb Sun, The Amber Sun
The Heavy Sun, The Windless Sun
The Ageless Sun, The Fruitful Sun

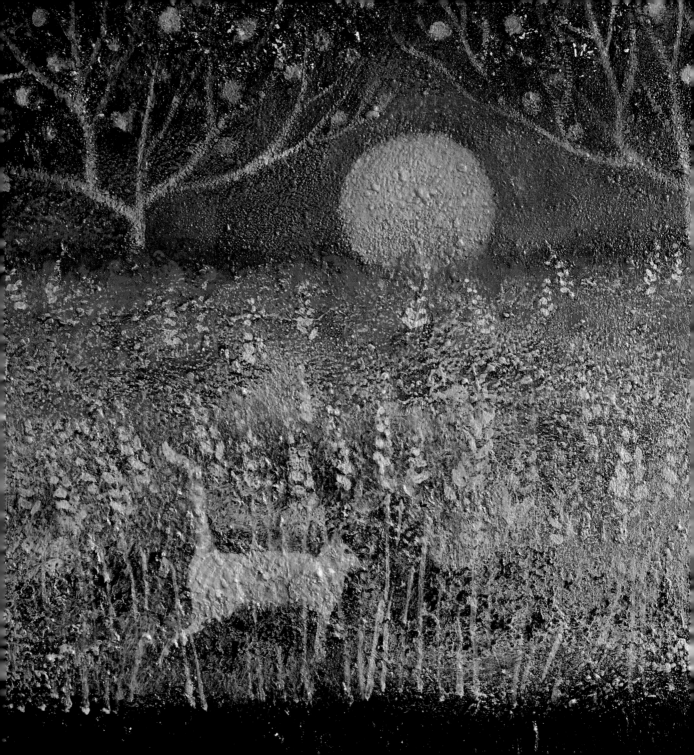

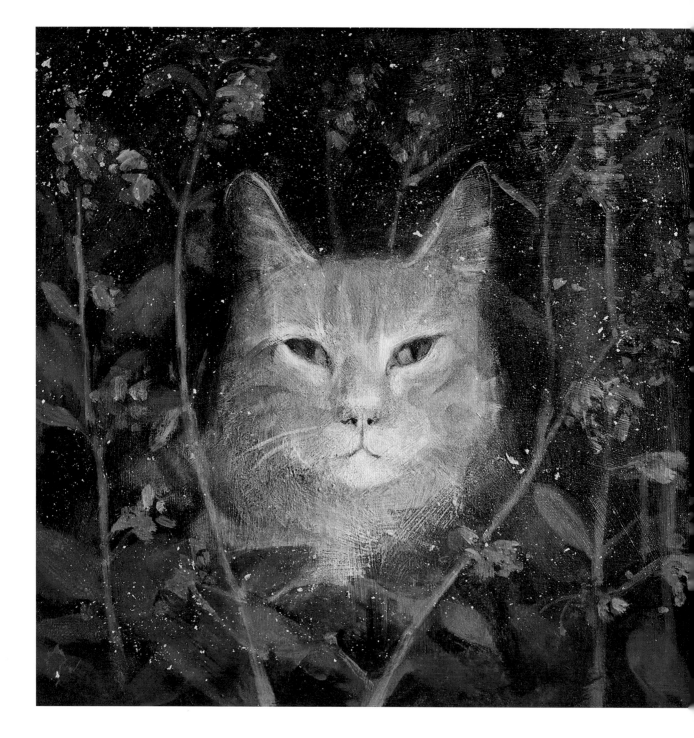

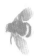

Also called: catswort and catmint, catnep, field balm,
catrup, nepeta, nip, cat's delight, herbe aux chats.

Used in tea and medicinally for humans, catnip can also
have a remarkable stimulating effect on cats.

It is a fantastic attractor of all pollinators and beloved by bees.

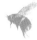

CATNIP

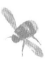

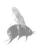

Also called: starflower, bee bush, bee bread, bugloss, tail wort, cool tankard.

The Ancient Greeks are said to have used borage to bring joy, rid themselves of melancholy and comfort the heart.

The Celtic 'borrach' means 'courage', perhaps leading to the old saying, 'Borage is for Courage'.

Borage is used as an herb, has edible flowers, and attracts pollinators to increase the yields of honey.

BORAGE

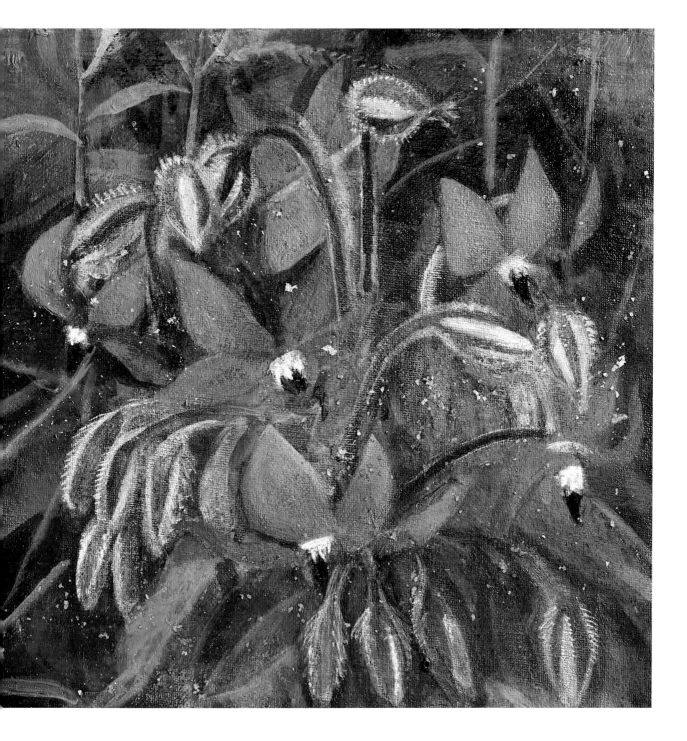

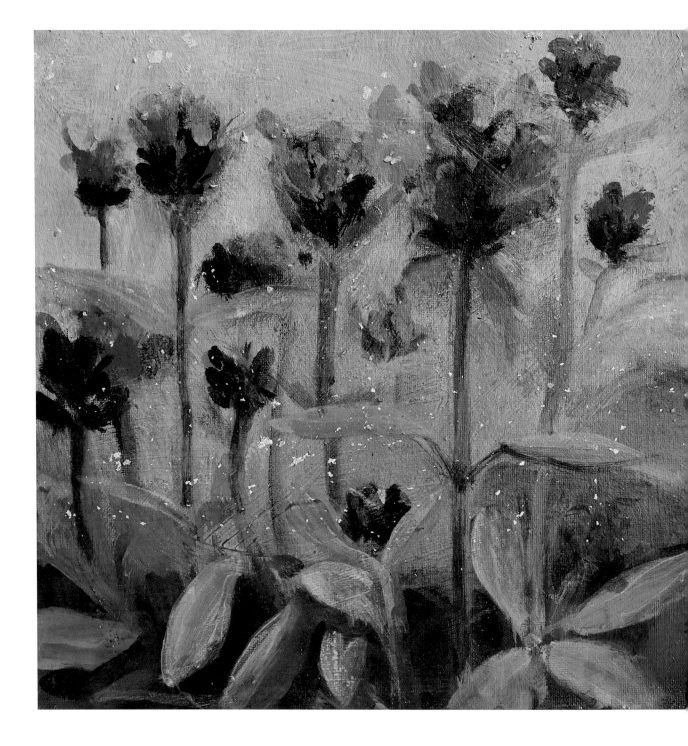

Also called: heal-all, woundwort, heart-of-the-earth, carpenter's herb and blue curls.

As its name suggests, selfheal has a long tradition of being used in herbal medicine for everything from stopping bleeding and healing wounds, to treating heart disease and a sore throat.

The Greeks believed that a baby whose lips were touched by a bee would become a great poet or speaker.

SELFHEAL

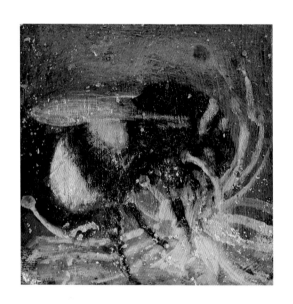

This is the place where the bee thrums.

SEPTEMBER

Warmed in Autumn's bronze perfume,
the dancing bees drink their fill.

And she hums,

The Harvest Sun, The Dusty Sun
The Amber Sun, The Indian Sun
The Corn-dolly Sun, The Benevolent Sun

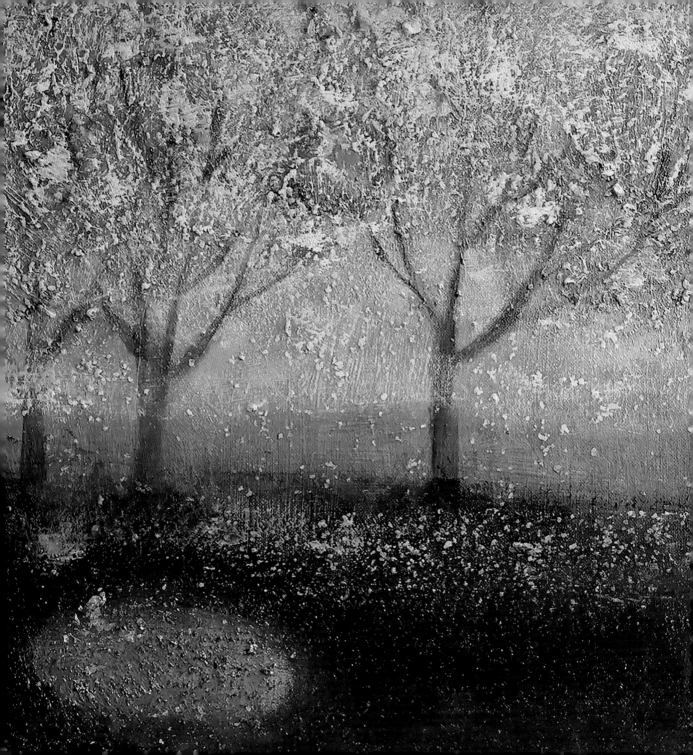

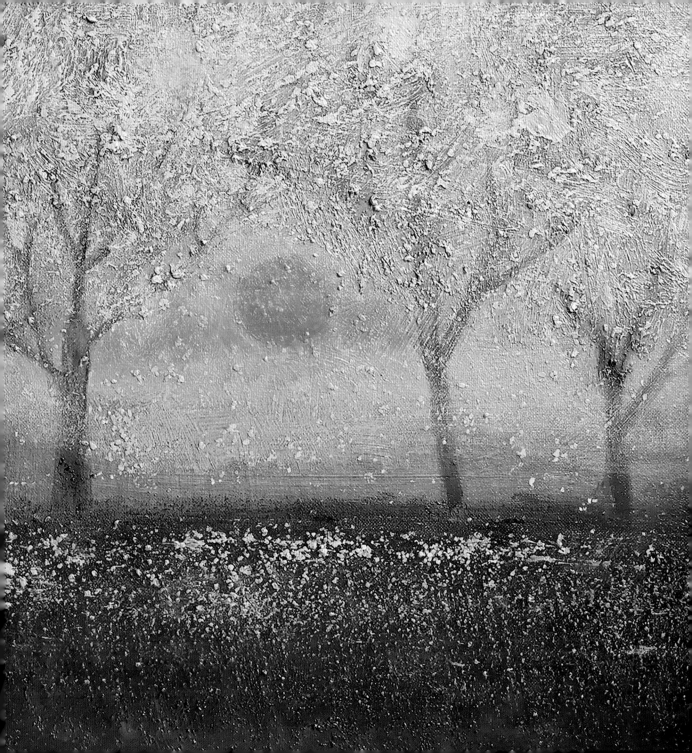

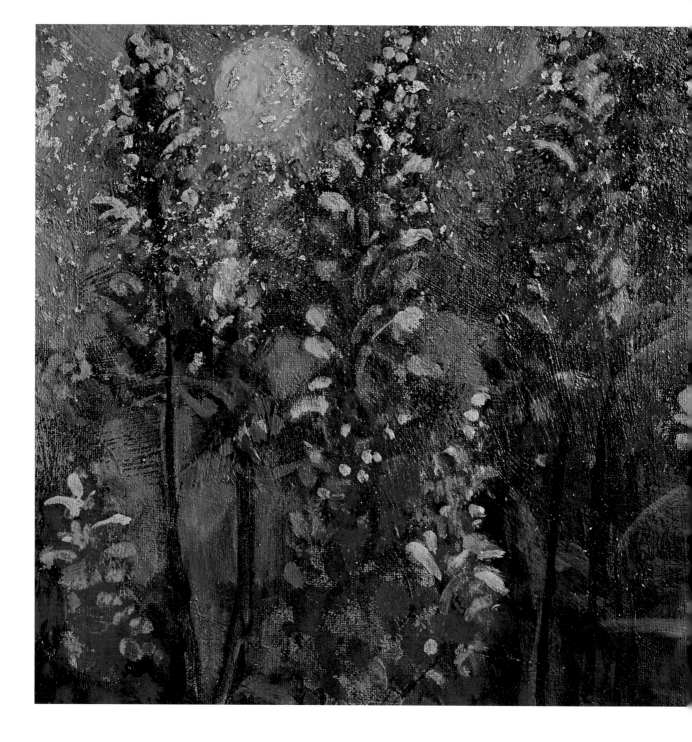

Mentioned in the Bible as a cleansing herb, hyssop was historically used as a fragrant strewing herb to freshen homes and protect against the plague.

In beekeeper traditions in both the UK and America, the hive must be kept abreast of family news – marriages, births, deaths: 'go tell the bees'.

Honey and bee venom are used in several different traditions of folk magic.

HYSSOP

Also called: pudding grass, mosquito plant, tickweed,
lurk in the ditch, flea mint, organ broth.

Sailors mixed pennyroyal with wormwood as a cure
for seasickness and to purify their drinking water.

Garlands of pennyroyal were worn about the head to
prevent headaches and giddiness and to help clear the mind.

An old saying goes, 'Ask the wild bee what the druid knows.'

PENNYROYAL

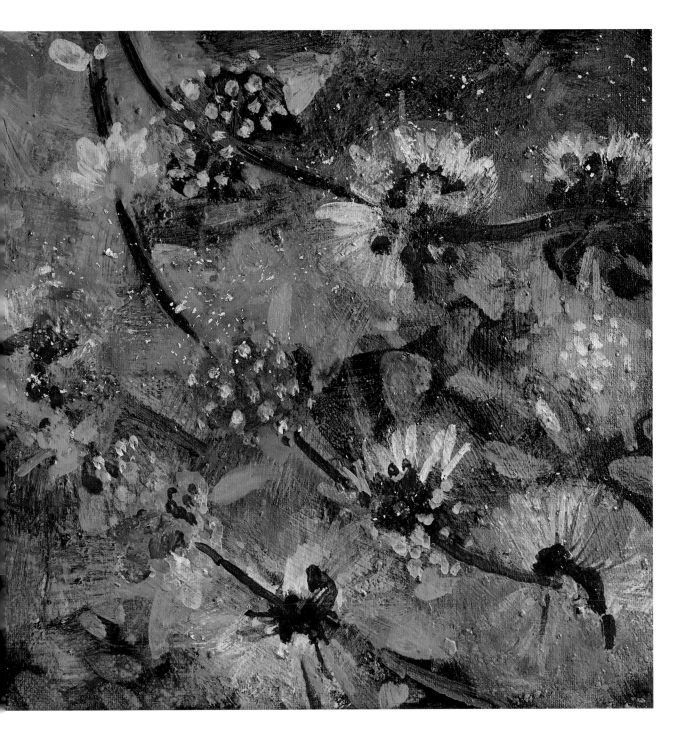

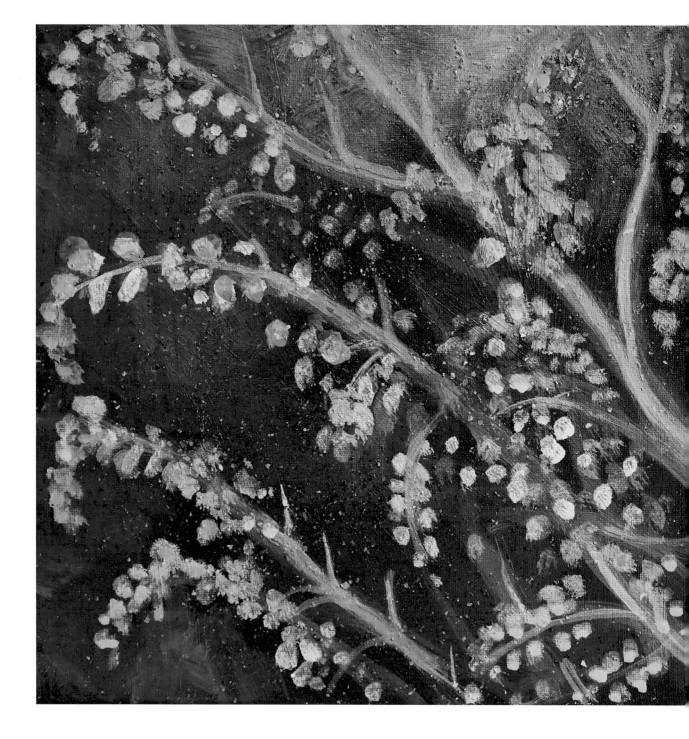

Also called: cronewort, wild wormwood, felon herb, sailor's tobacco, Artemis Herb, naughty man, old man, Muggins.

Mugwort is among the herbs in The Nine Herbs Charm, an Anglo-Saxon herbal healing spell from the 10th century.

Mugwort has long been associated with midsummer and the magic of witches and is said to offset travellers' fatigue when placed in the shoes before setting out.

MUGWORT

This is the place where the bee harvests.

OCTOBER

Earth folds into herself.
The gentle Pleiades sink beneath the horizon,
Orion strides into winter.

And she hums,

The Saffron Sun, The Cooling Sun
The Vermillion Sun, The Autumn Sun
The Stormy Sun, The Late Sun

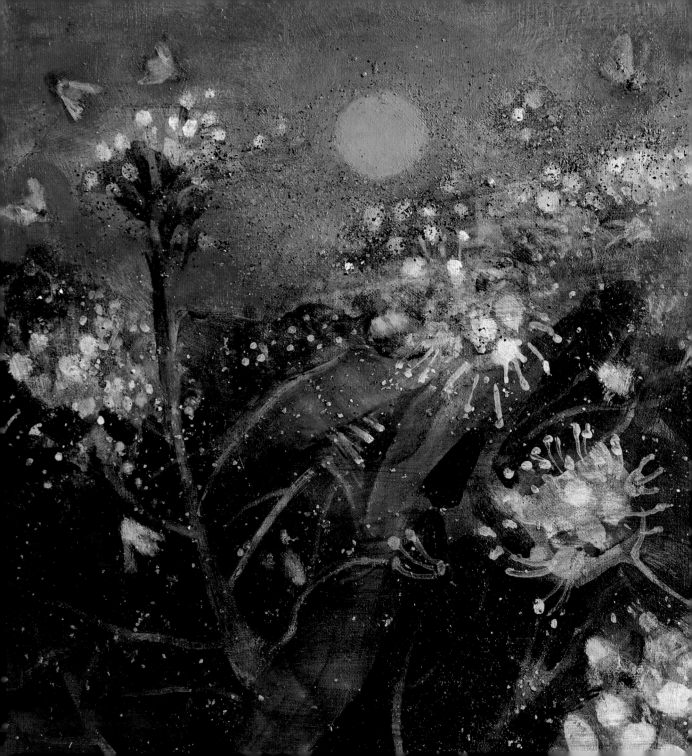

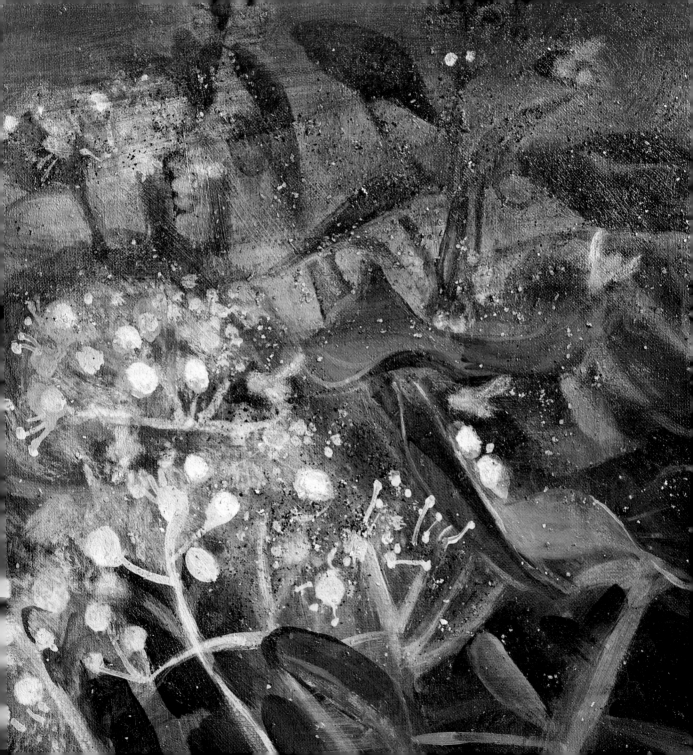

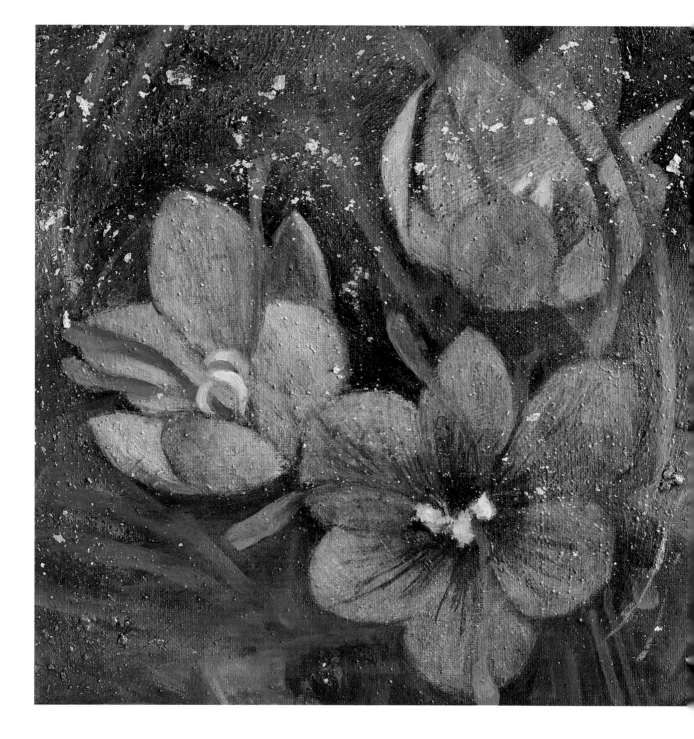

The name saffron comes from the Arabic word 'za'faran', meaning yellow.

Aromatic, exotic and expensive, saffron is harvested from the flower of the saffron crocus.

Saffron is as precious as gold and often used as a sign of wealth and prosperity.

Still used and grown today in Cornwall to flavour saffron buns and bread, it is thought that saffron was brought to Cornwall by the Phoenicians, who exchanged it for Cornish-mined tin and copper.

SAFFRON

Also called: St Brid's comb, devil's plaything, woundwort, common hedge nettle, lousewort, bishop's wort, bishop's elder, wild hop.

During the Middle Ages, betony was planted in churchyards and worn in amulets. It was thought to guard against evil spirits and mischief.

Place betony underneath your pillow to ward off nightmares.

BETONY

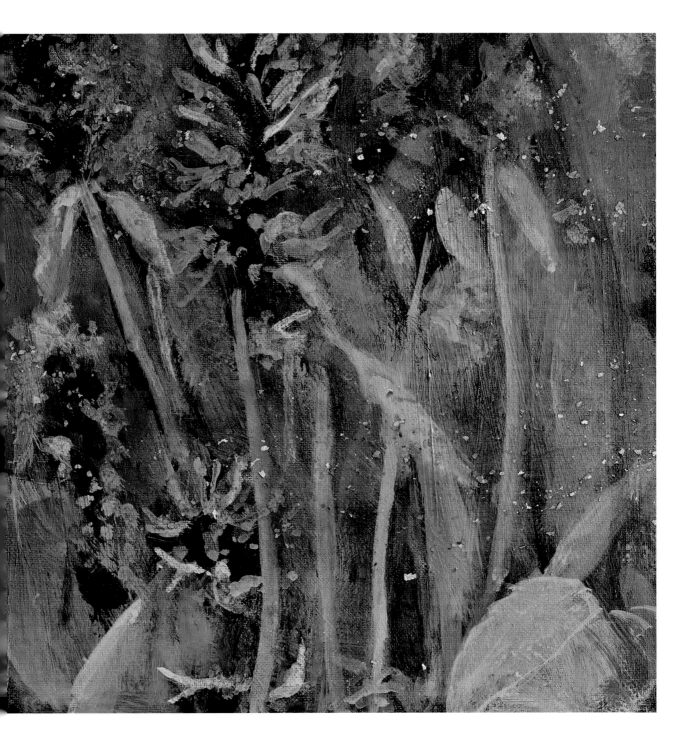

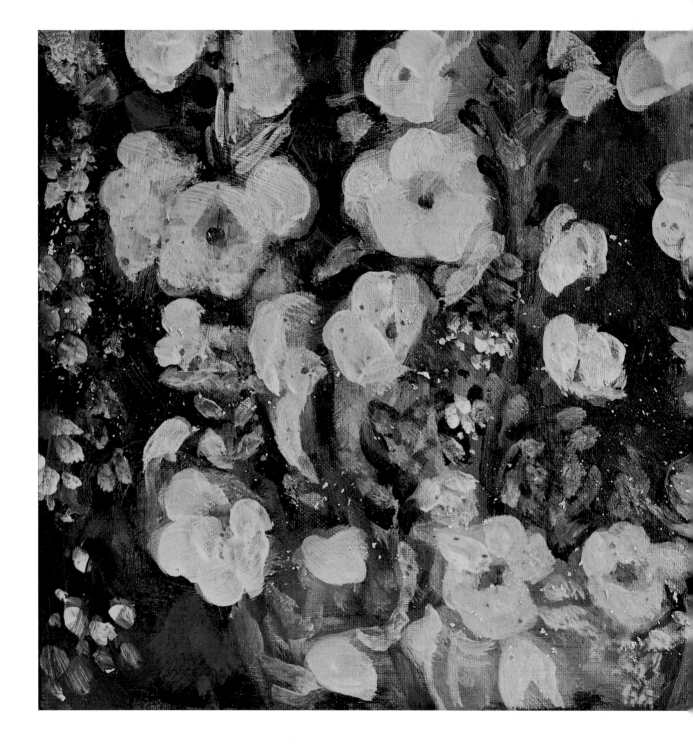

Also called: velvet dock, blanket herb, woollen rag, candlewick plant, Jupiter's staff, hare's beard, hag's taper.

Historically used as a treatment for coughs, congestion and inflammation.

The custom of using mullein for torches dates back at least to Roman times.

Witches were said to use mullein spikes to fly to their night-time meetings.

'Dumbledore' is an old English (Cornish) word for bumblebee.

MULLEIN

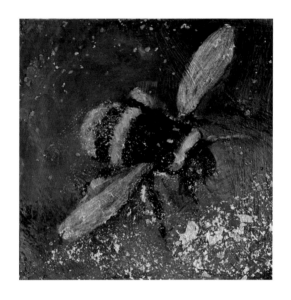

This is the place where the bee rests.

NOVEMBER

Days shorten.
The Earth cools, answering the four voices of the wind.

And she hums,

The Copper Sun, The Ageless Sun
The Vermillion Sun, The Cooling Sun
The Quiet Sun, The Ice Sun

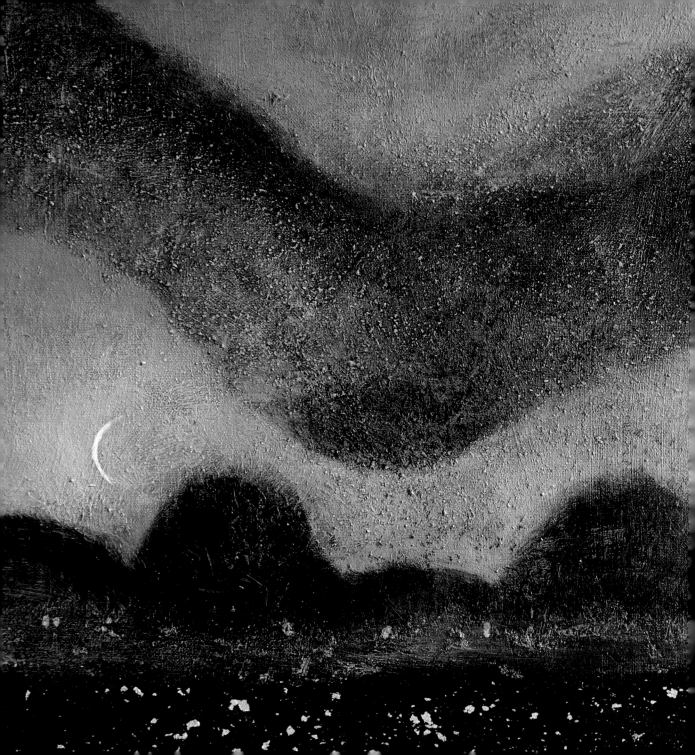

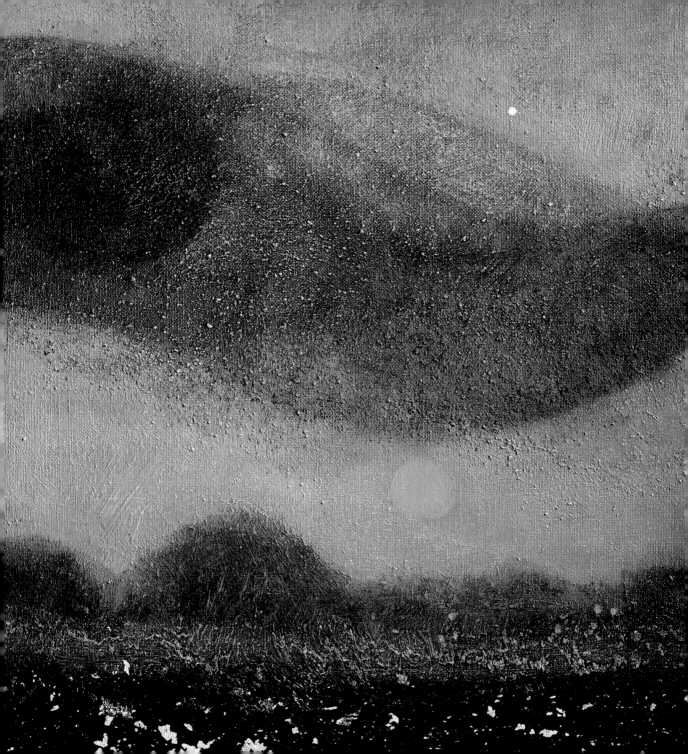

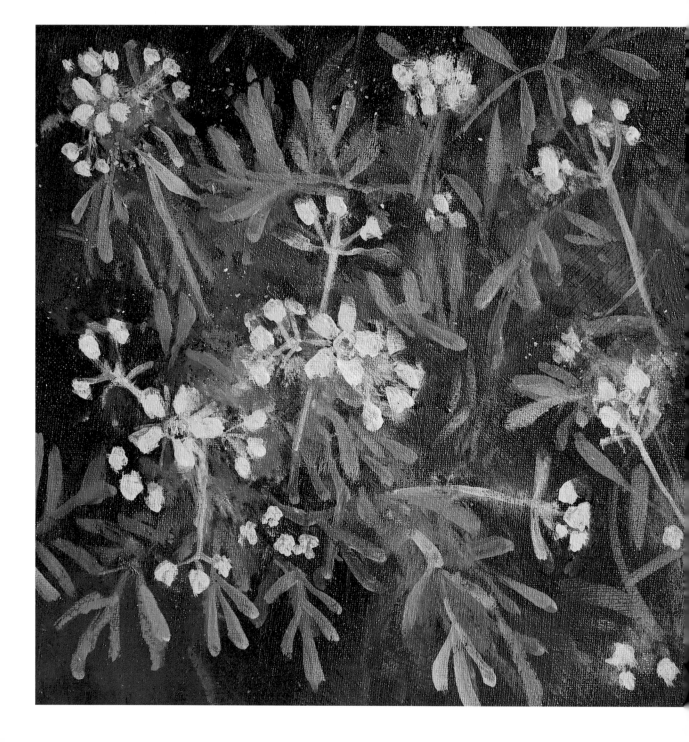

Also called: herb-of-grace, herbygrass, garden rue, blessed herb, herb of repentance.

Rue has long been used in medicine and magic.

Early physicians considered rue an excellent protection against plagues and pestilence. It was frequently planted by doorways to bring blessings and to protect against evil and witches.

Michelangelo and Leonardo da Vinci regularly ate the leaves of rue to improve their eyesight and creativity.

RUE

Also called: mentha, bee-plant.

In Greek mythology, Mentha was a nymph beloved of Pluto. His jealous wife Persephone turned her into a humble plant upon which Pluto then bestowed its sweet smell so that her scent would perfume the air when trodden upon.

Gerard described mint as having a 'smelle rejoyceth the heart of man'.

Used as a strewing herb in medieval times for its scent and to repel insects.

MINT

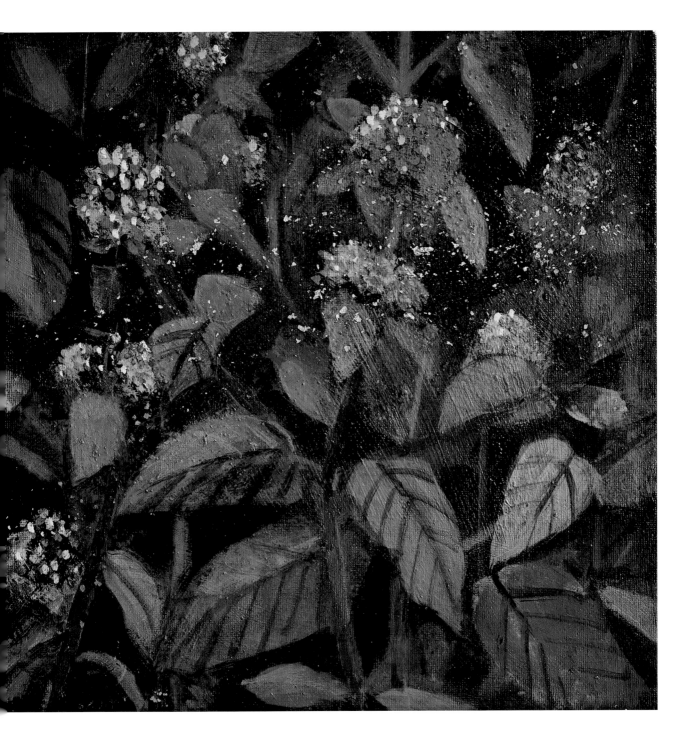

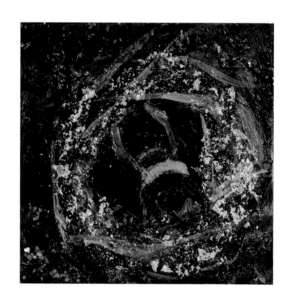

This is the place where the bee stills.

DECEMBER

Under the moon,
a new queen dreams, meadow sweet,
rich with secrets.

And she hums,

The Cinnamon Sun, The Solstice Sun
The Luminous Sun, The Old Sun
The Gorgeous Sun,
The Eternal Sun

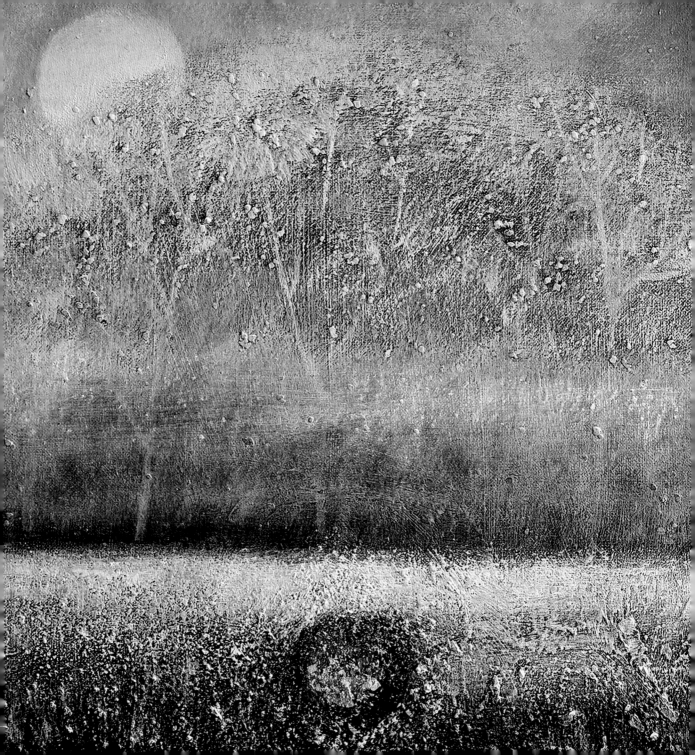

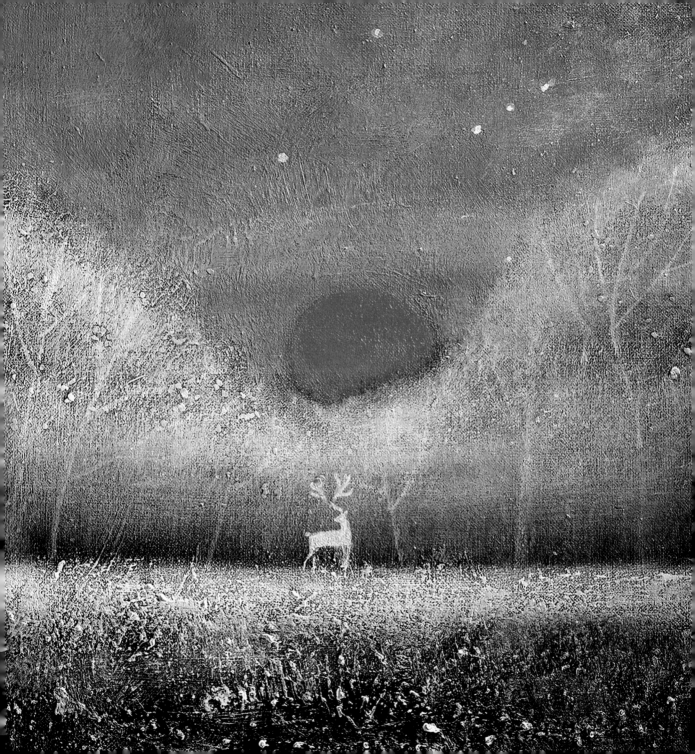

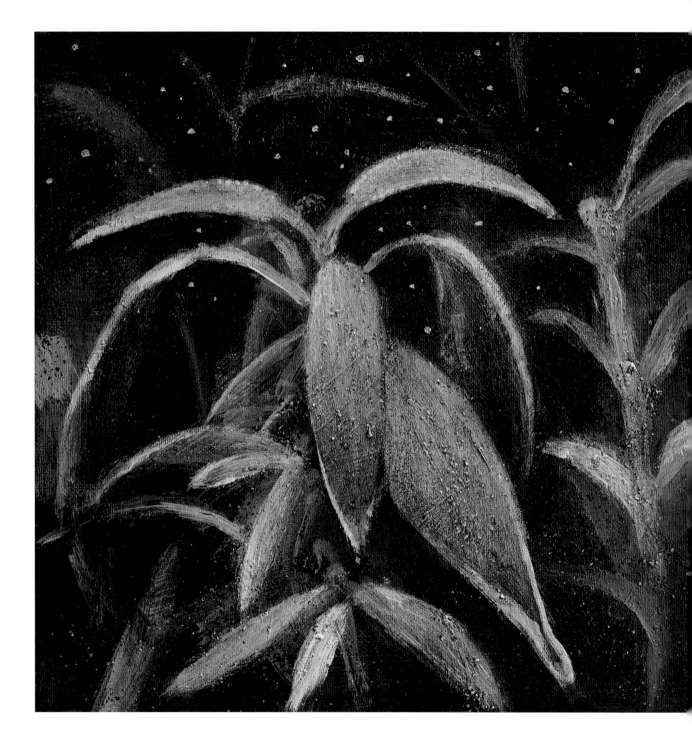

Also called: common sage, garden sage, golden sage, kitchen sage, true sage, culinary sage, Dalmatian sage, and broadleaf sage.

The scientific name for sage is salvia from the Latin 'salveo', 'to heal' or 'to save'.

Sage was regarded by the Romans as a holy herb and a cure for almost all diseases.

As well as its medicinal use, the herb was traditionally used to preserve meat, help with fertility and even grant immortality.

'He that would live for aye, must eat Sage in May.'

SAGE

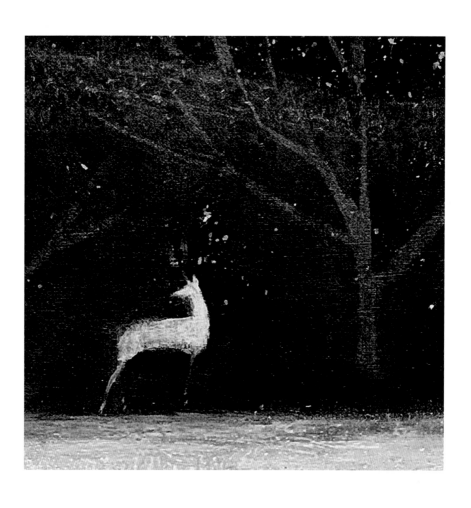

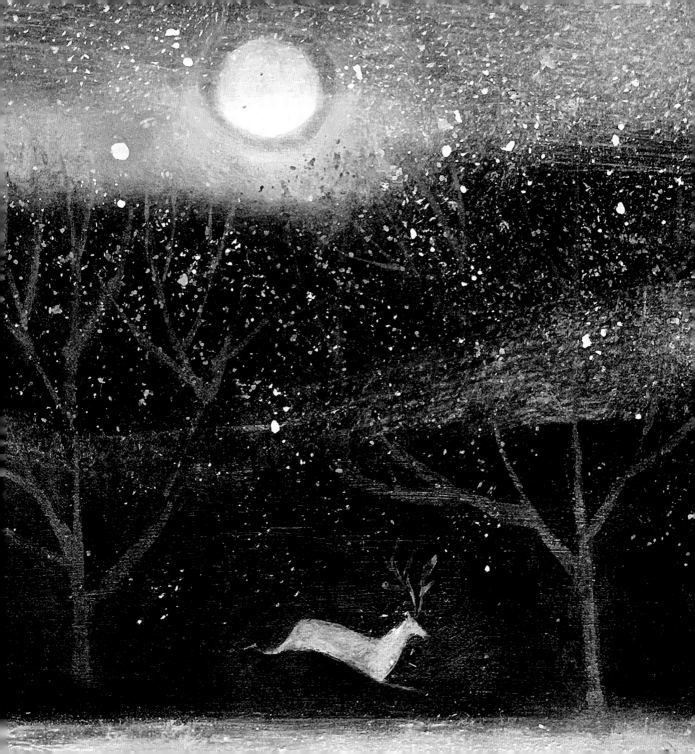

This is the place where the bee sleeps.

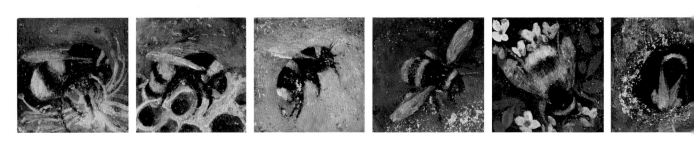

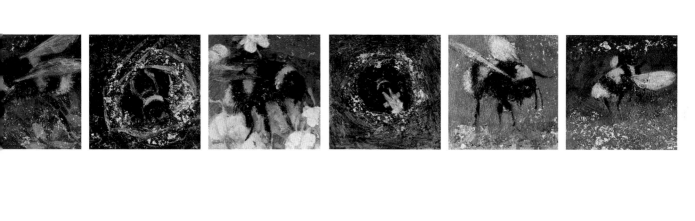

There are around 20,000 described bee species worldwide. Most of these bees are known as solitary bees with only 250 bumblebee species, nine honeybee species and a number of social stingless bees worldwide.

In Britain, we have around 270 species of bee, just under 250 of which are solitary bees.

All social and solitary bees build nests in a variety of places with over 70% of bees building their nests by digging in the ground.

Bees actually have four wings – the two wings on each side hook together to form one large pair when flying and then unhook when they aren't flying.

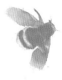

About
THE BEES

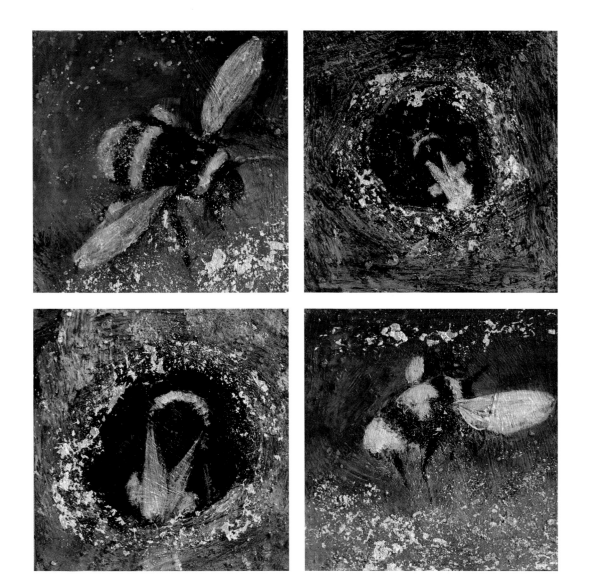

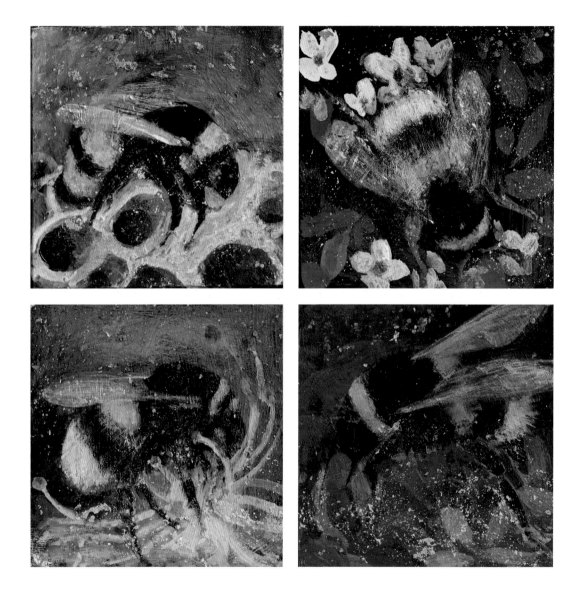

Bumblebees have the ability to use their 'smelly footprints' to distinguish between their own scent, the scent of a relative and the scent of a stranger. This allows them to improve their success in finding food and avoiding flowers that have already been visited.

Certain species of bees will dance to communicate with each other.

90% of our wildflowers depend on bees for pollination.

Bees benefit other living things by pollinating plants, which in turn helps maintain our food supply. Without bees to spread pollen, it's estimated that a significant percentage of crops, and thus food, would vanish from our planet.

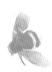

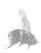

The WILDLIFE TRUSTS

'In the UK, our insect populations have suffered drastic declines, which are set to have far-reaching consequences for both wildlife and people.

With a third of our food crops pollinated by insects, and as many as 87% of our plants pollinated by animals (and in the majority by insects), there is a lot to lose. Much of our wildlife, be it birds, bats, reptiles, amphibians, small mammals or fish, rely on insects for food. Without them, we risk the collapse of our natural world.

A report, *Insect Declines and Why They Matter*, published in November 2019 by an alliance of Wildlife Trusts in the south-west, brought together evidence that showed the loss of 50% or more of our insects since 1970, and the shocking reality that 41% of the Earth's remaining five million insect species are now "threatened with extinction".

It is essential that there is a halt to the unnecessary use of pesticides where people live, work and farm.'

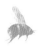

How to HELP

One of the best ways to help bees is to create your own bee-friendly garden. There is an abundance of information on the web including these sites:

Friends of the Earth – friendsoftheearth.uk
The Wildlife Trusts – wildlifetrusts.org
WWF – wwf.org.uk
The Bee Conservancy – thebeeconservancy.org
The National Wildlife Federation – nwf.org
Green Peace – greenpeace.org.uk
The Bumblebee Conservation Trust – bumblebeeconservation.org

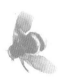

'She is, if you will, a visual poet weaving images, symbols and archetypes into paintings that resonate in the subconscious and linger there like half-remembered dreams or the dark fairy stories with which she has such affiliation.' Pip Palmer, *Galleries Magazine*.

Artist and award-winning illustrator Catherine Hyde trained in Fine Art Painting at Central School of Art in London and exhibits and sells her atmospheric and symbolic work in galleries far and wide.

Catherine lives with her family in Cornwall, and works at the top of her house in her studio 'in the sky'. *The Bee and the Sun* is a companion to *The Hare and the Moon*, published in 2019.

All her picture books have been nominated for the prestigious Kate Greenaway Award, and she was the winner of The English Association Best Illustrated Book Award (Key Stage 2) for *The Princess' Blankets* by Carol Ann Duffy.

About THE ARTIST
CATHERINE HYDE

Some of my earliest memories are of my mother's garden, a paradise of herbs and flowers and the buzzing of bees and insects. I find the glorious aromas of freshly picked mint, rosemary and oregano powerfully nostalgic and it fills me with pleasure to gather them now from my own wildflower garden.

This collection of paintings is a celebration of my deep love for the cycles of the seasons and a dedication to the profound importance of the bee as a pollinator in our world.

Catherine Hyde
Cornwall, 2021

I paint with acrylics on a fine tooth canvas and build the picture surface with layers of glazes, adding thickening gels, copper and gold leaf and mica flakes for extra texture. The bees and herbs are embellished with 24ct gold leaf.

I like to move the picture structure around, keeping it fluid and mobile, so that the final image retains energy and atmosphere.

About THE WORK
THE BEE & THE SUN

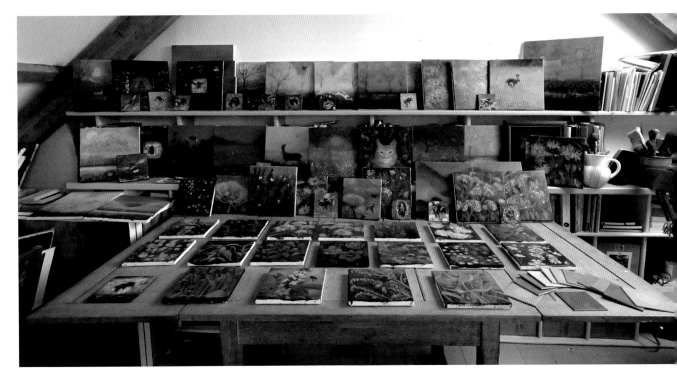

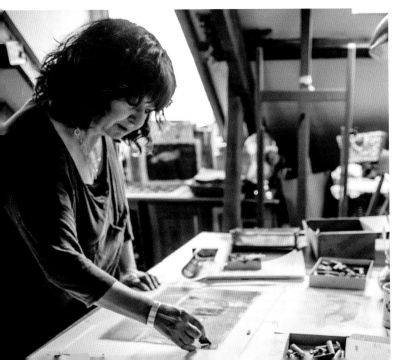

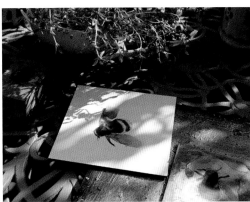

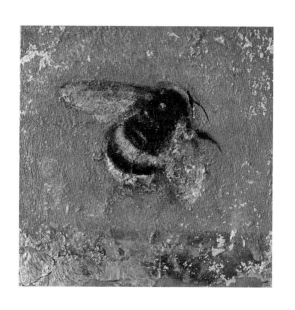